Mandala Designs
Samantha Moore

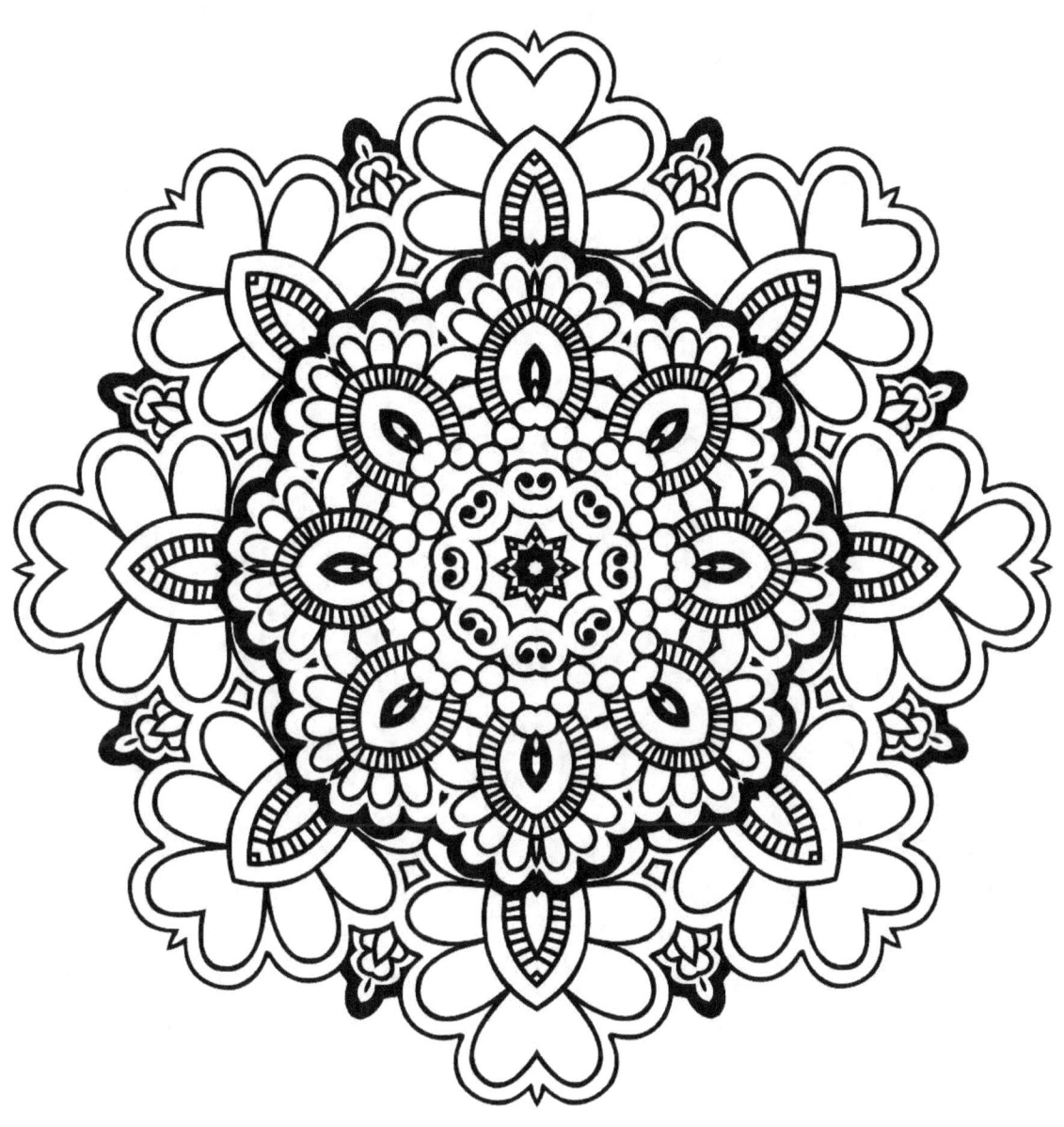

Inspiring and relaxing
Adult Coloring Book

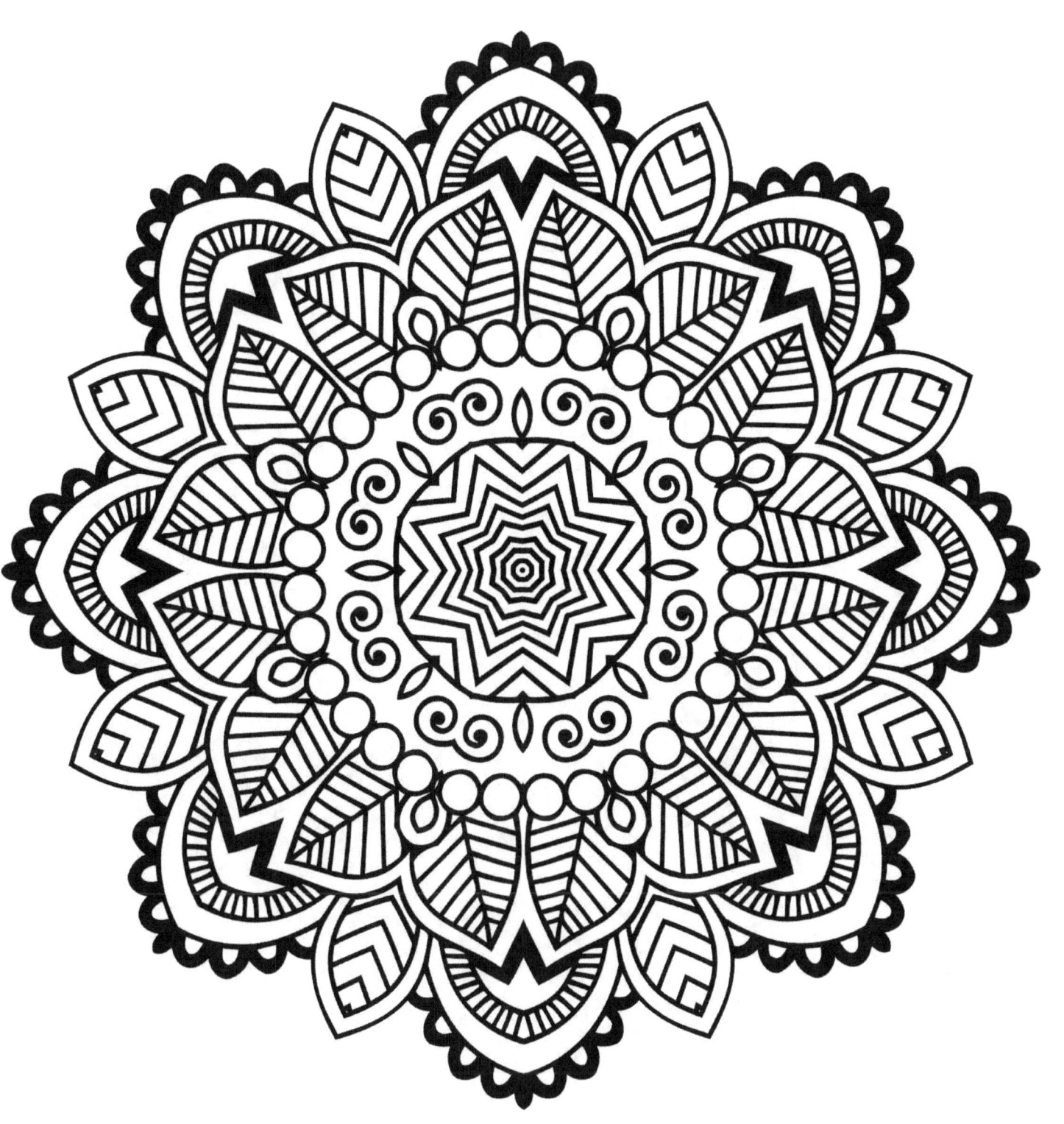

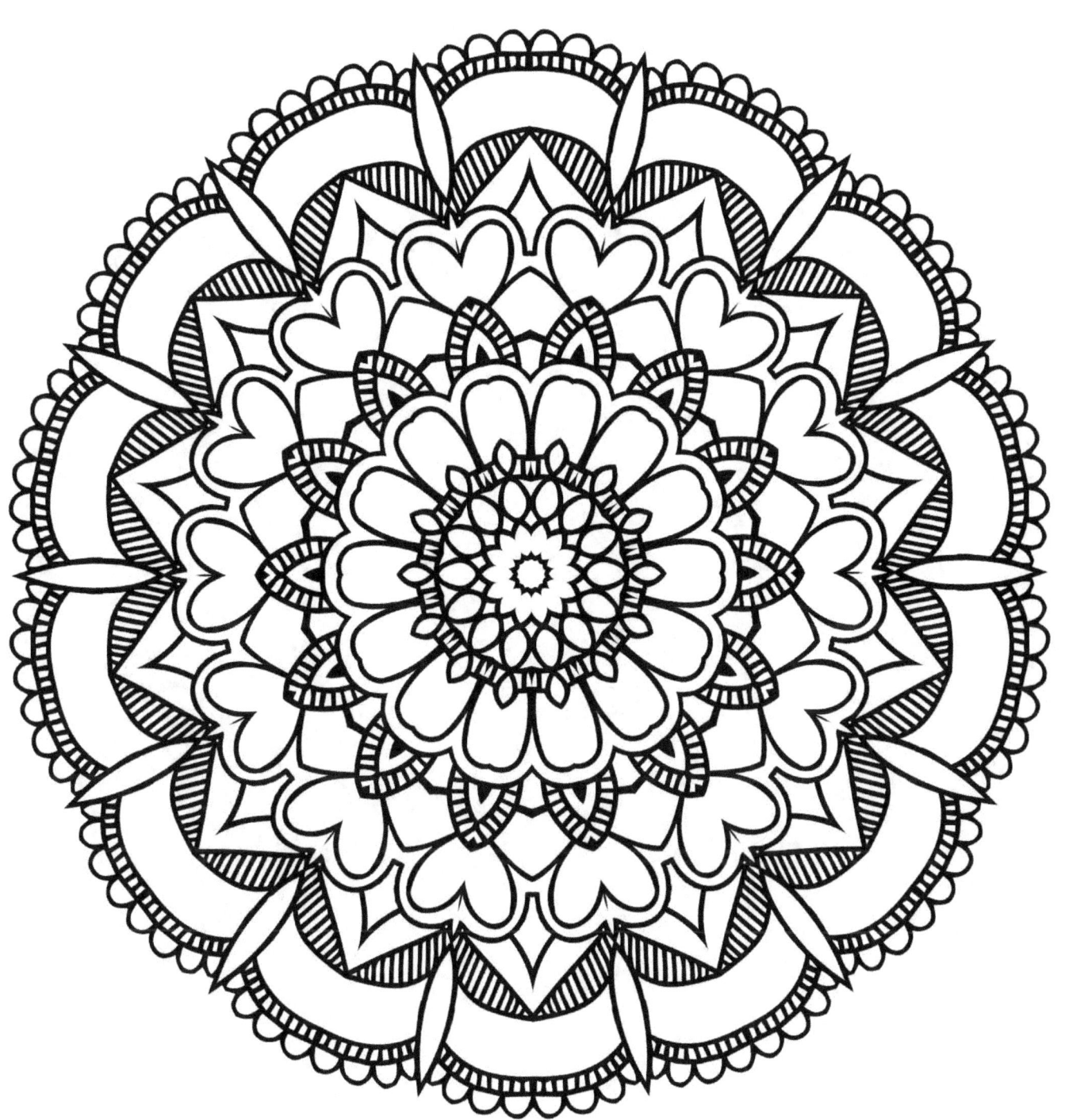

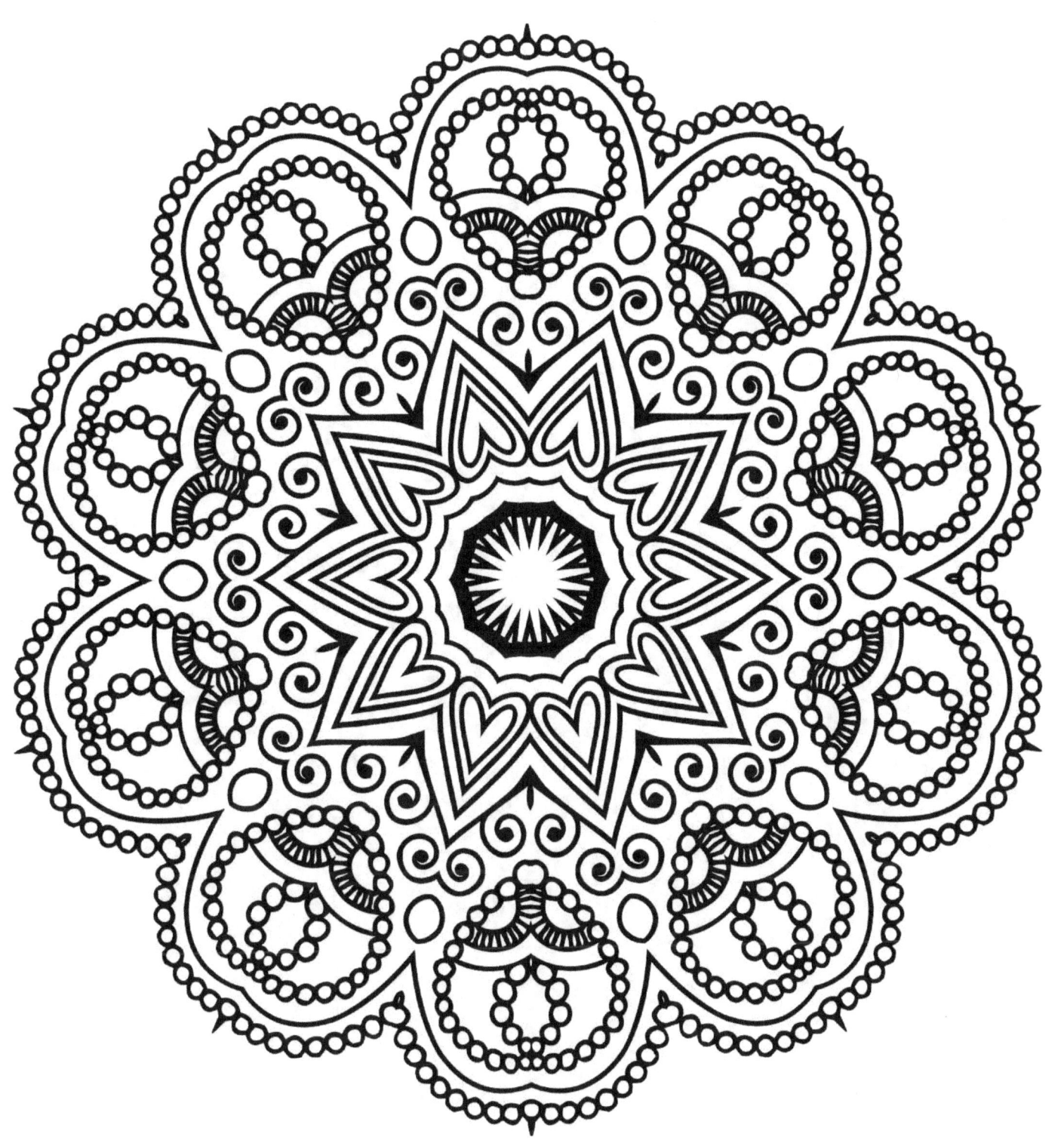

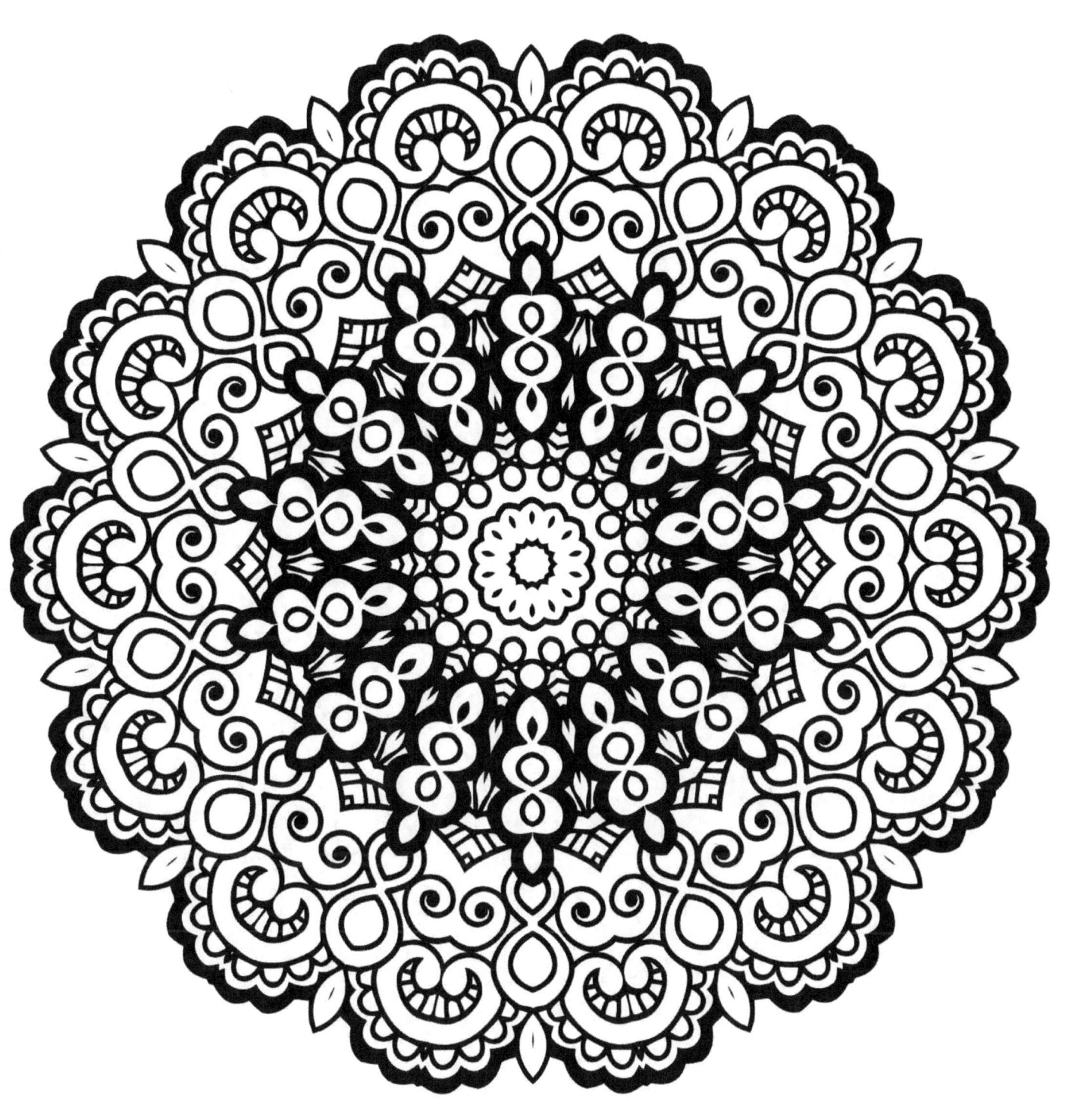

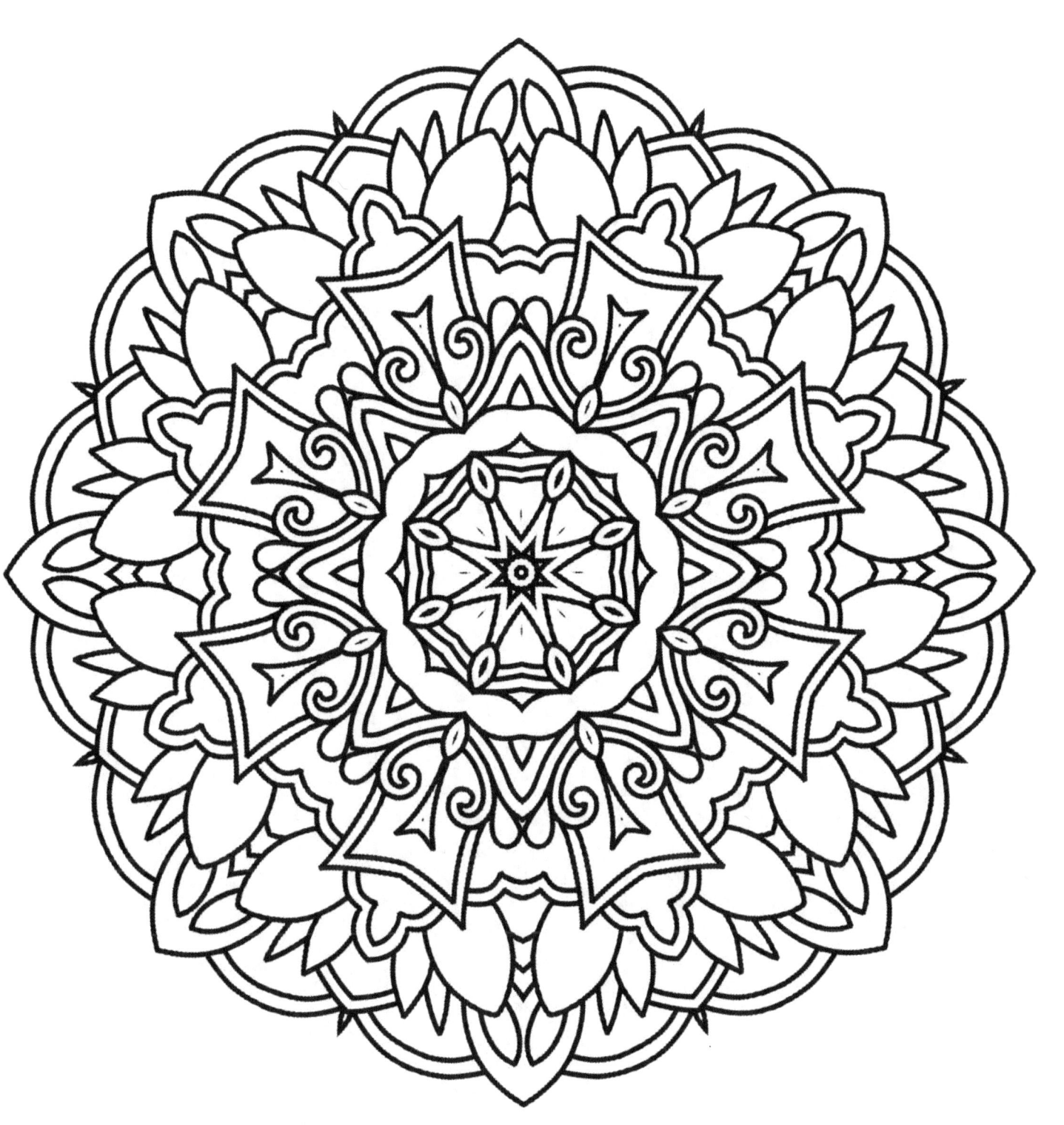

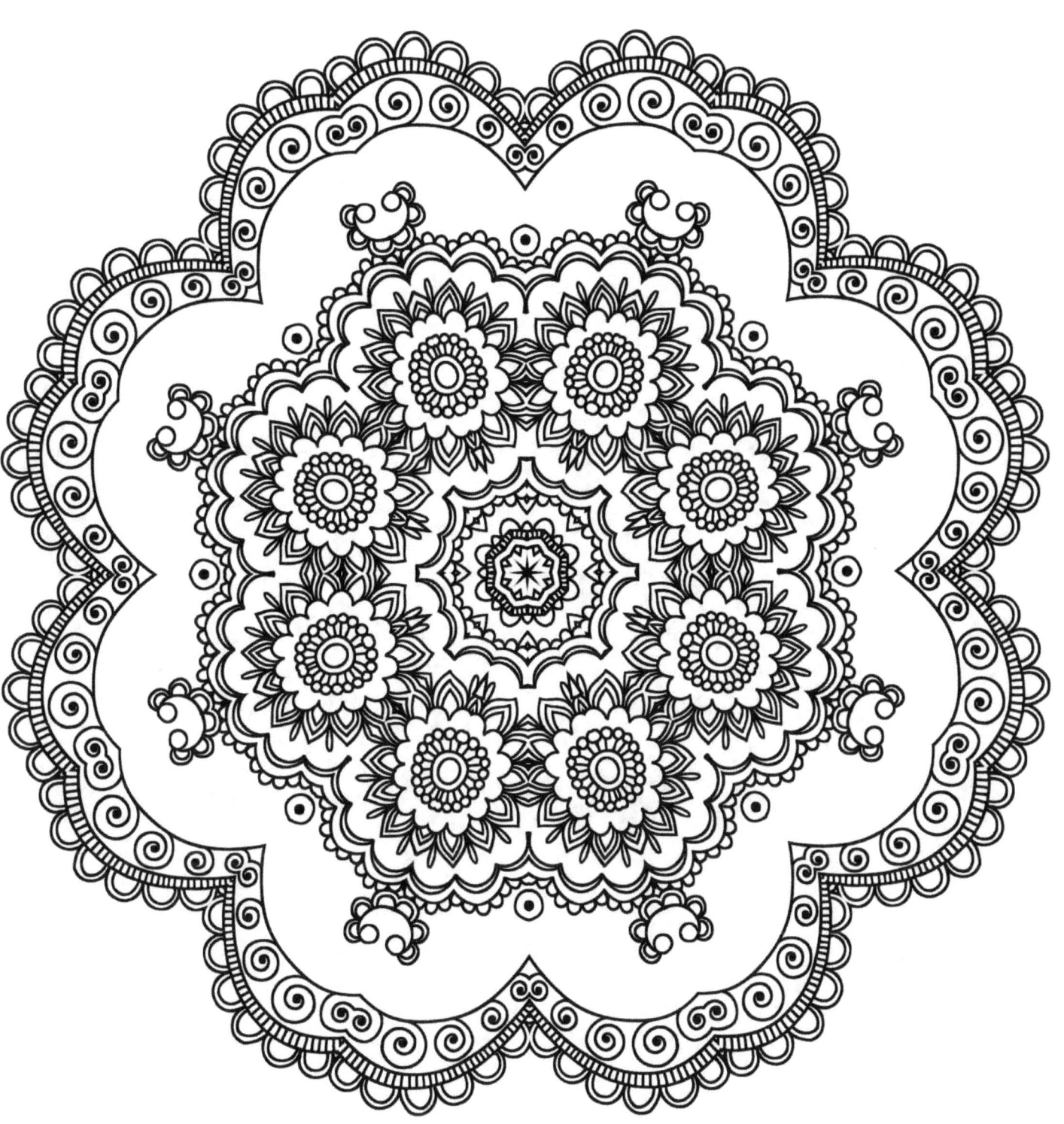

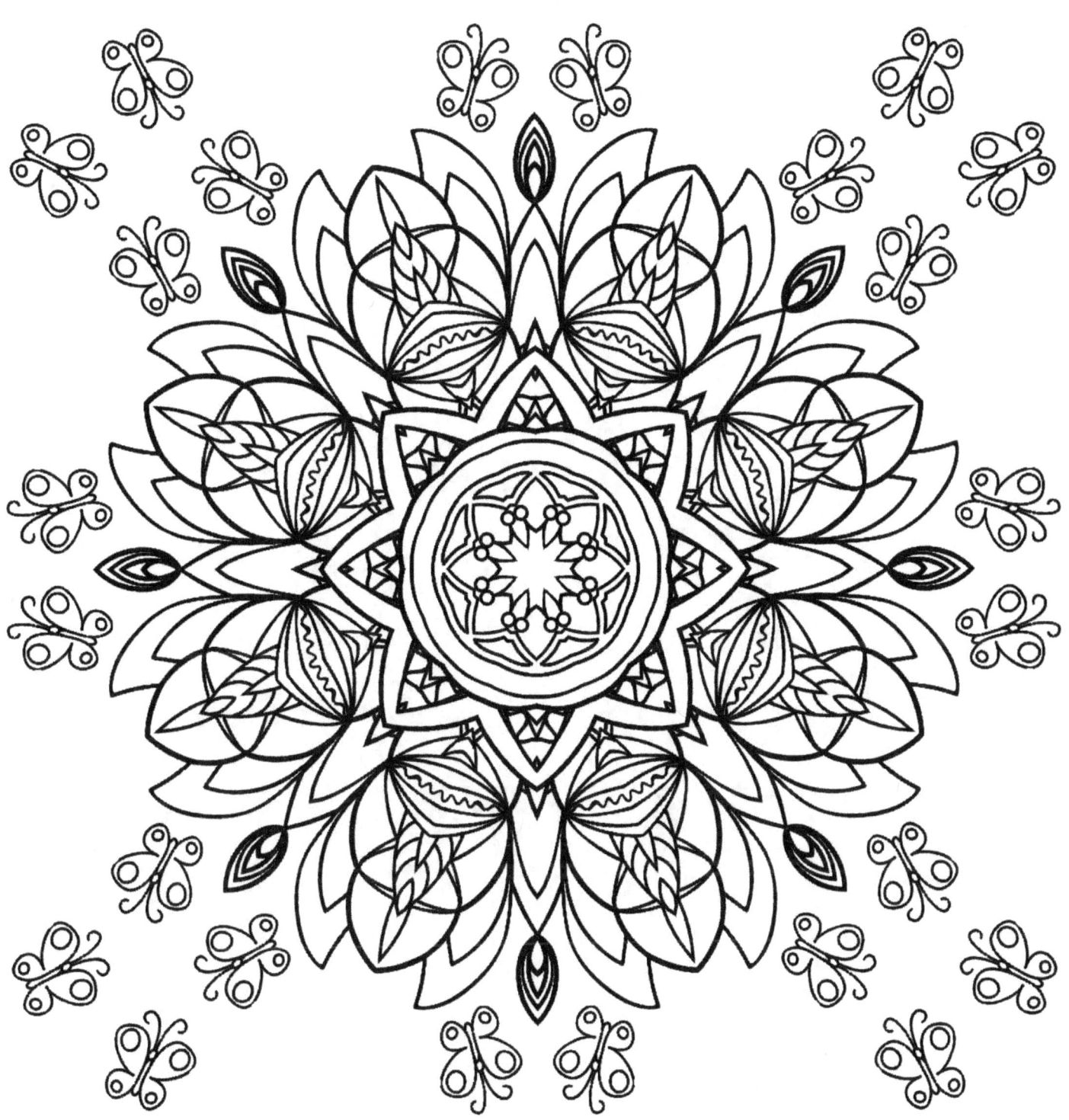

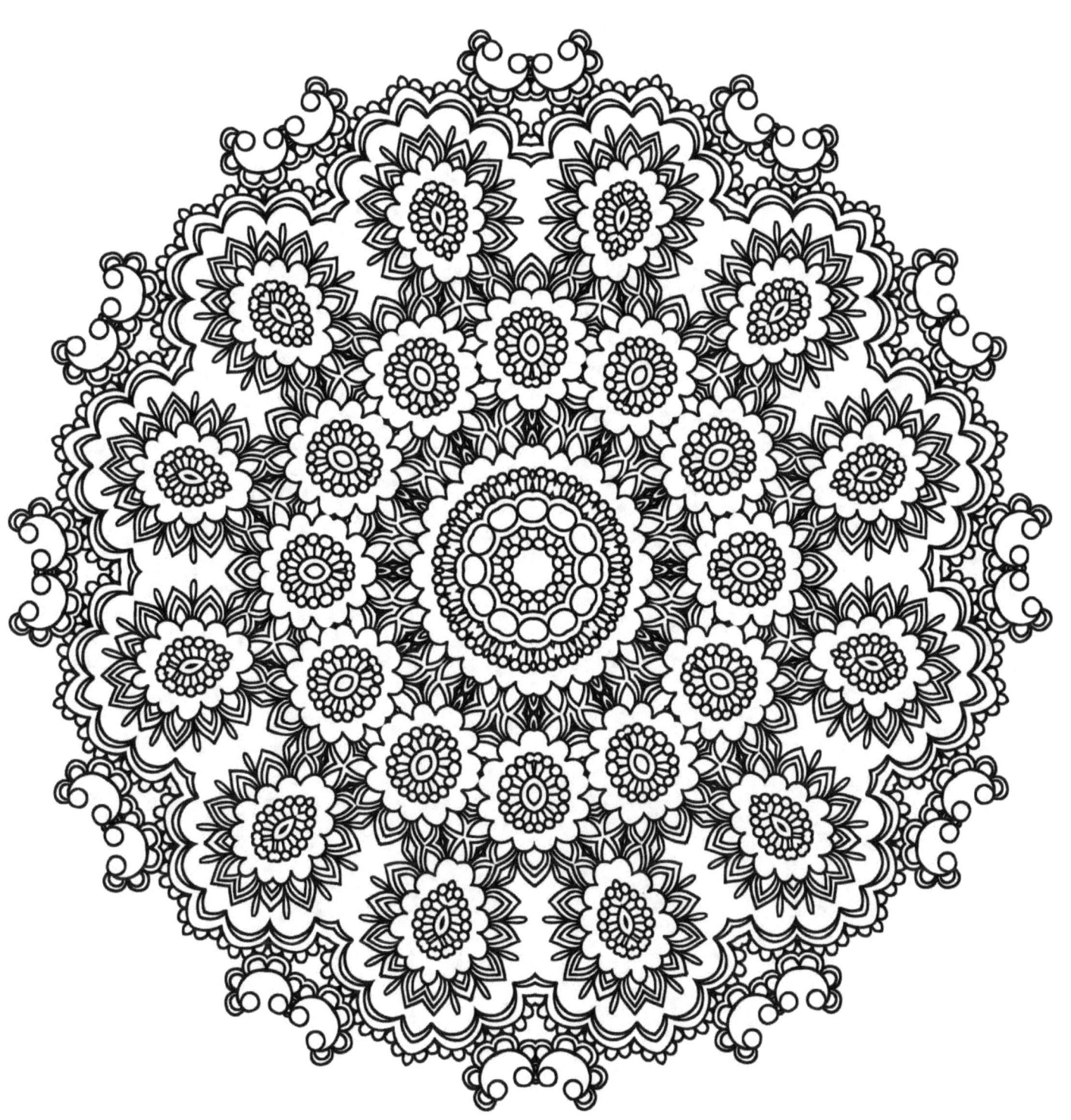

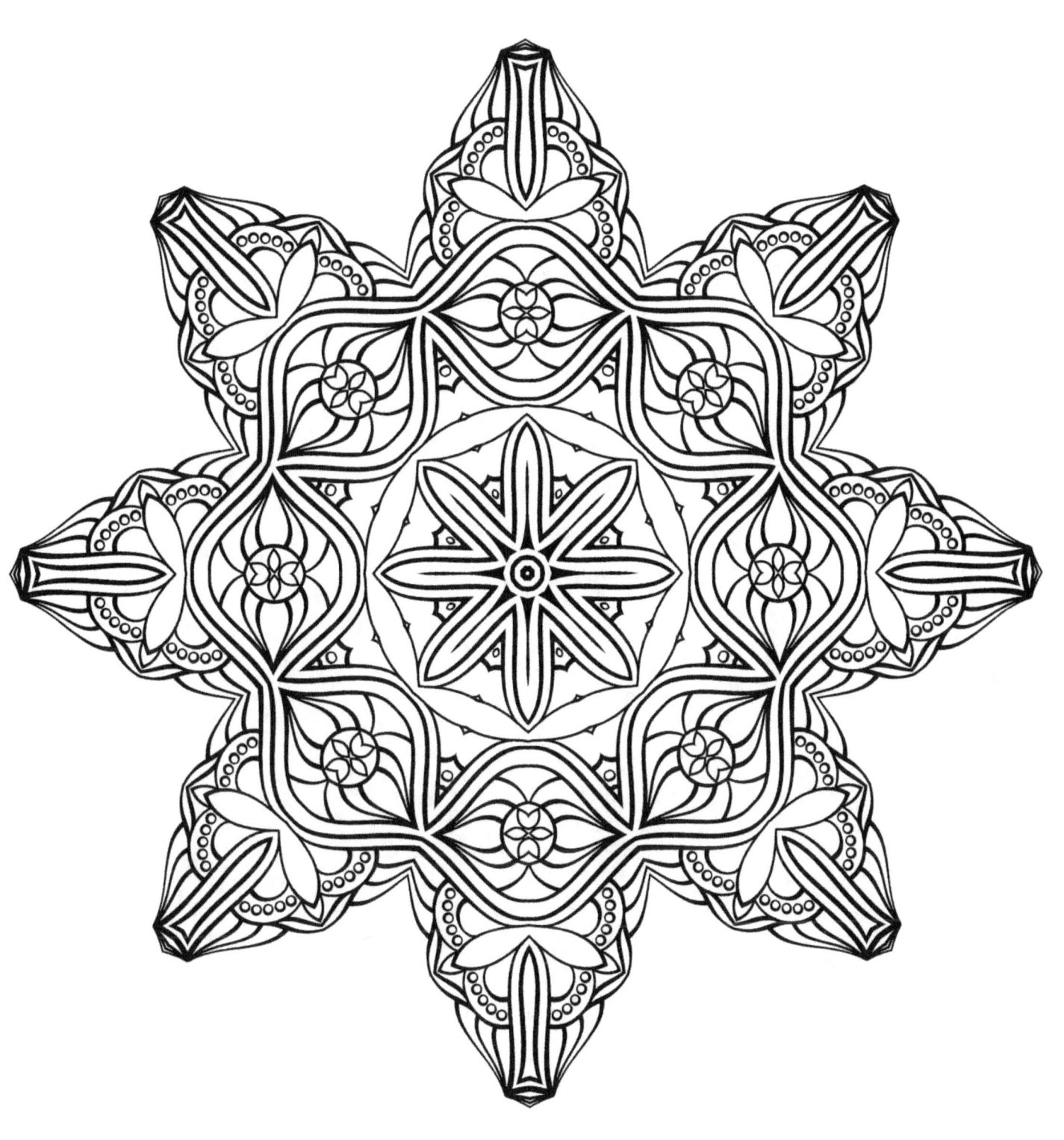

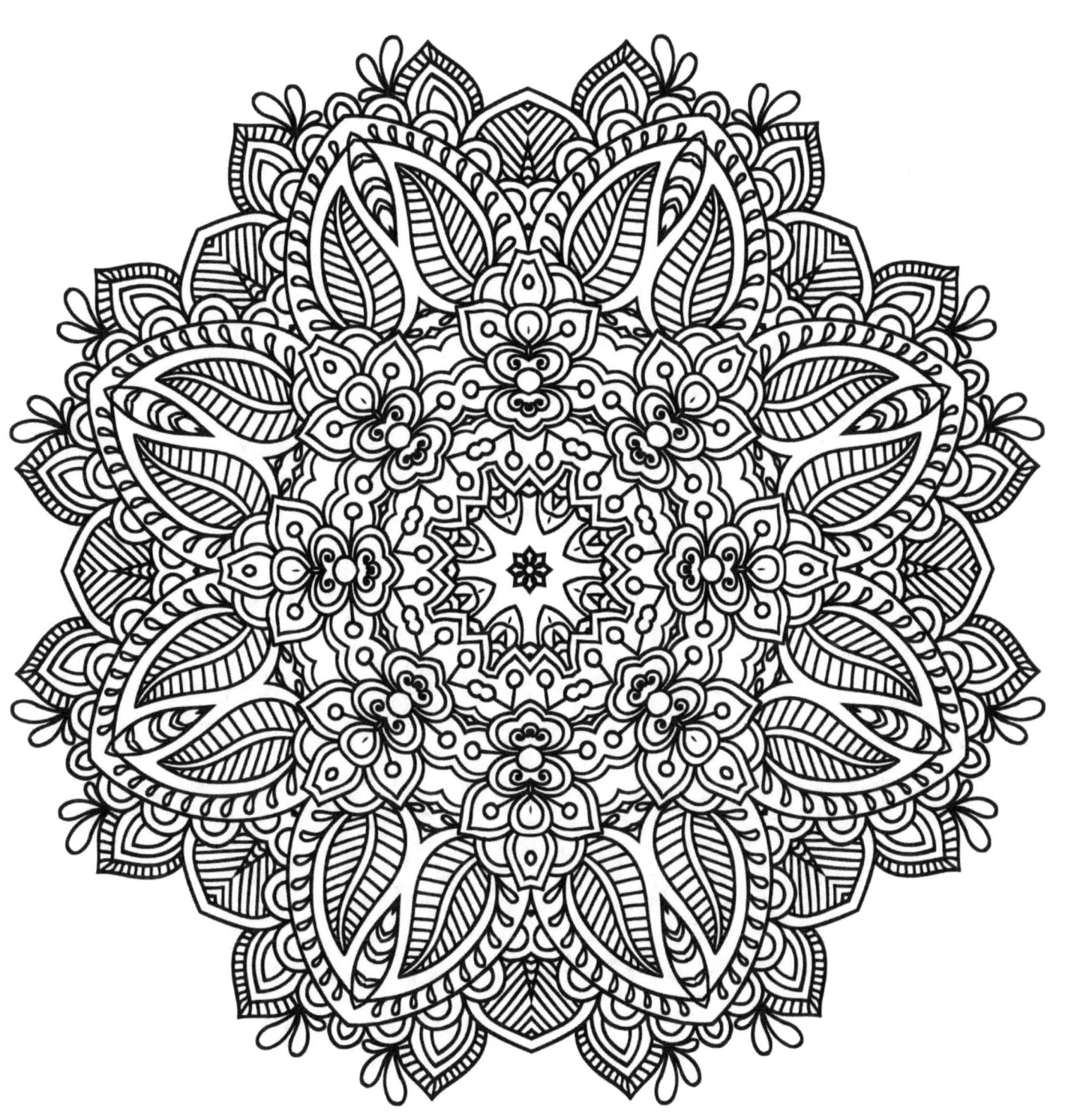

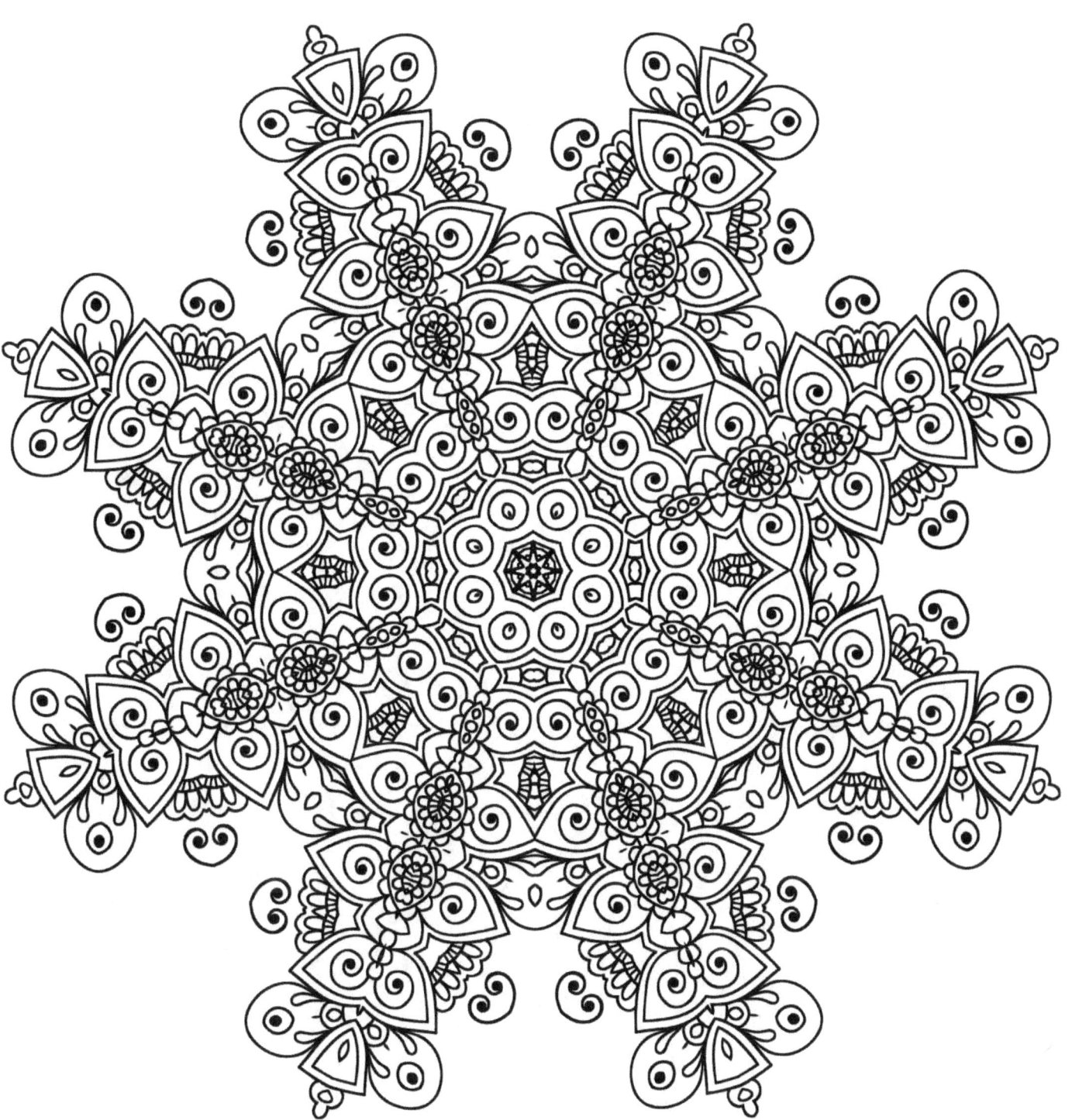

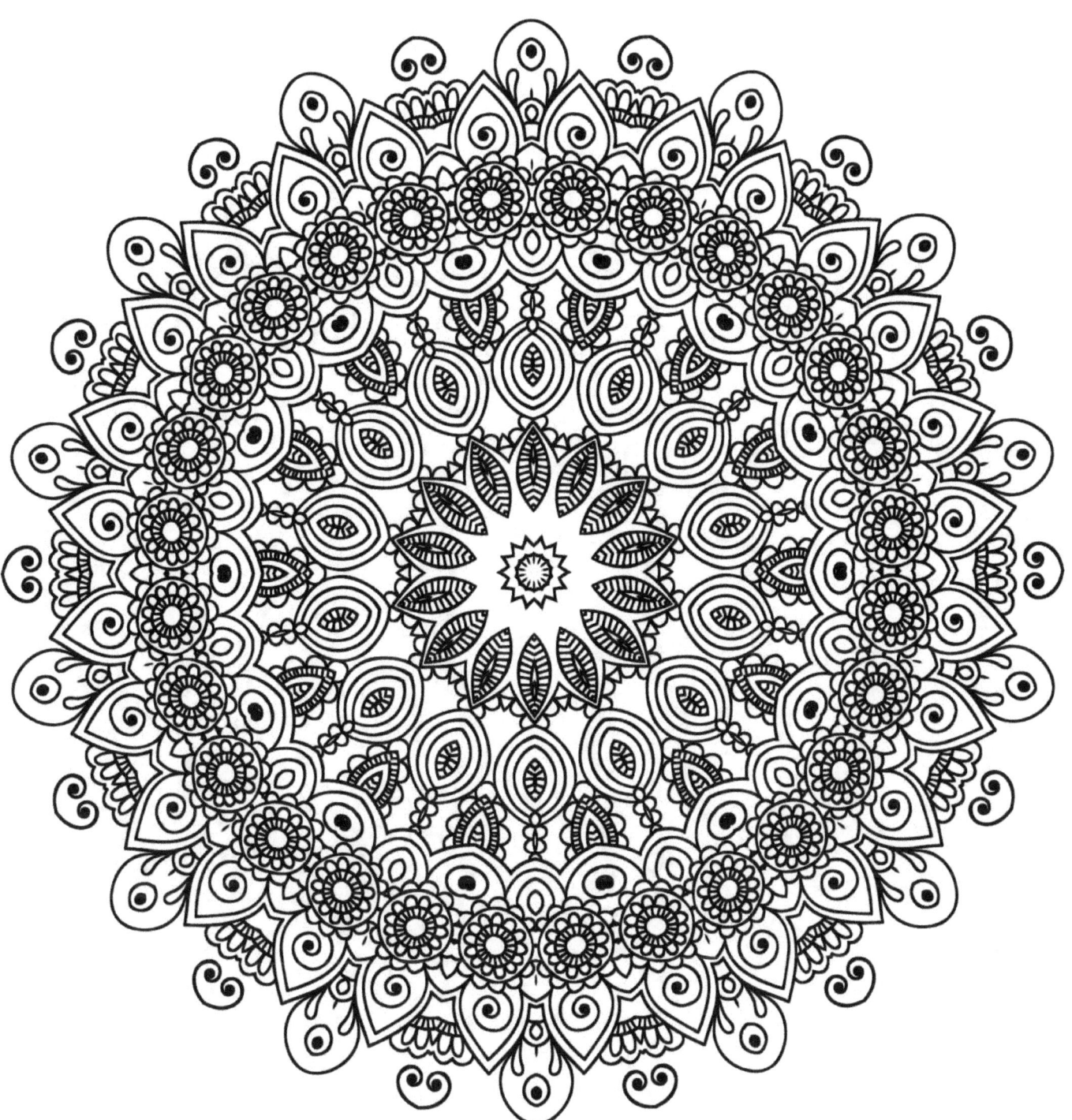

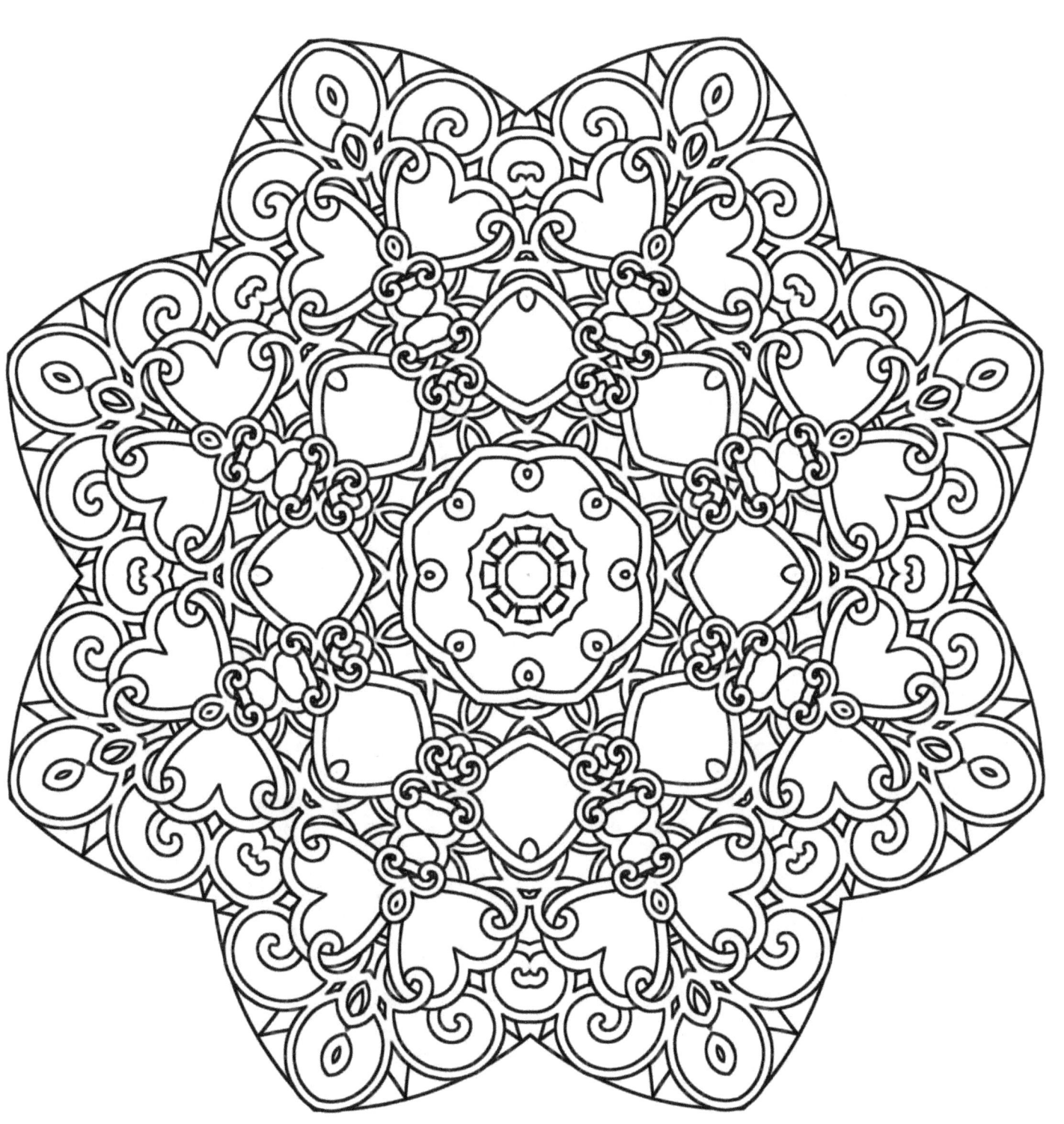

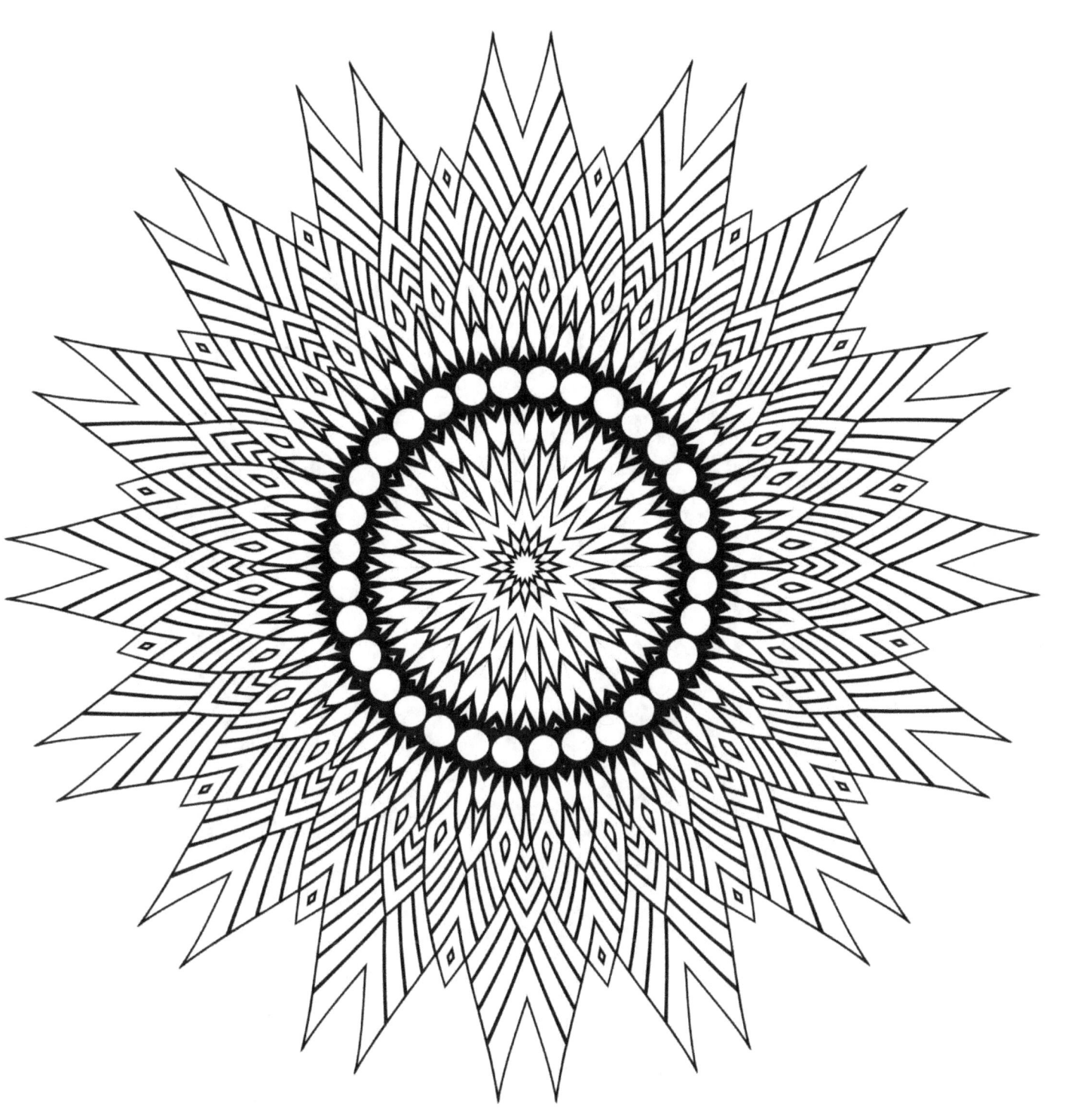

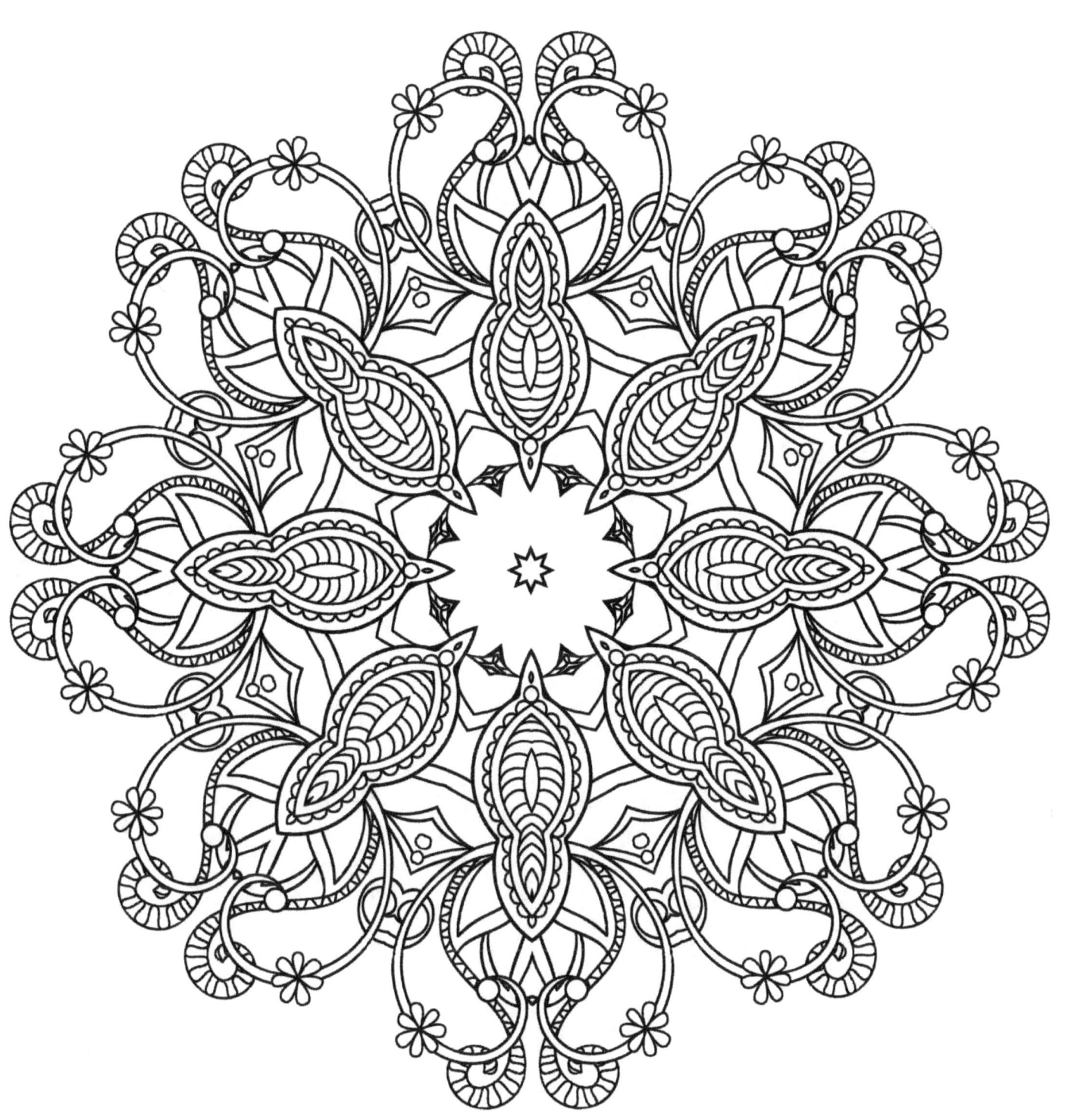

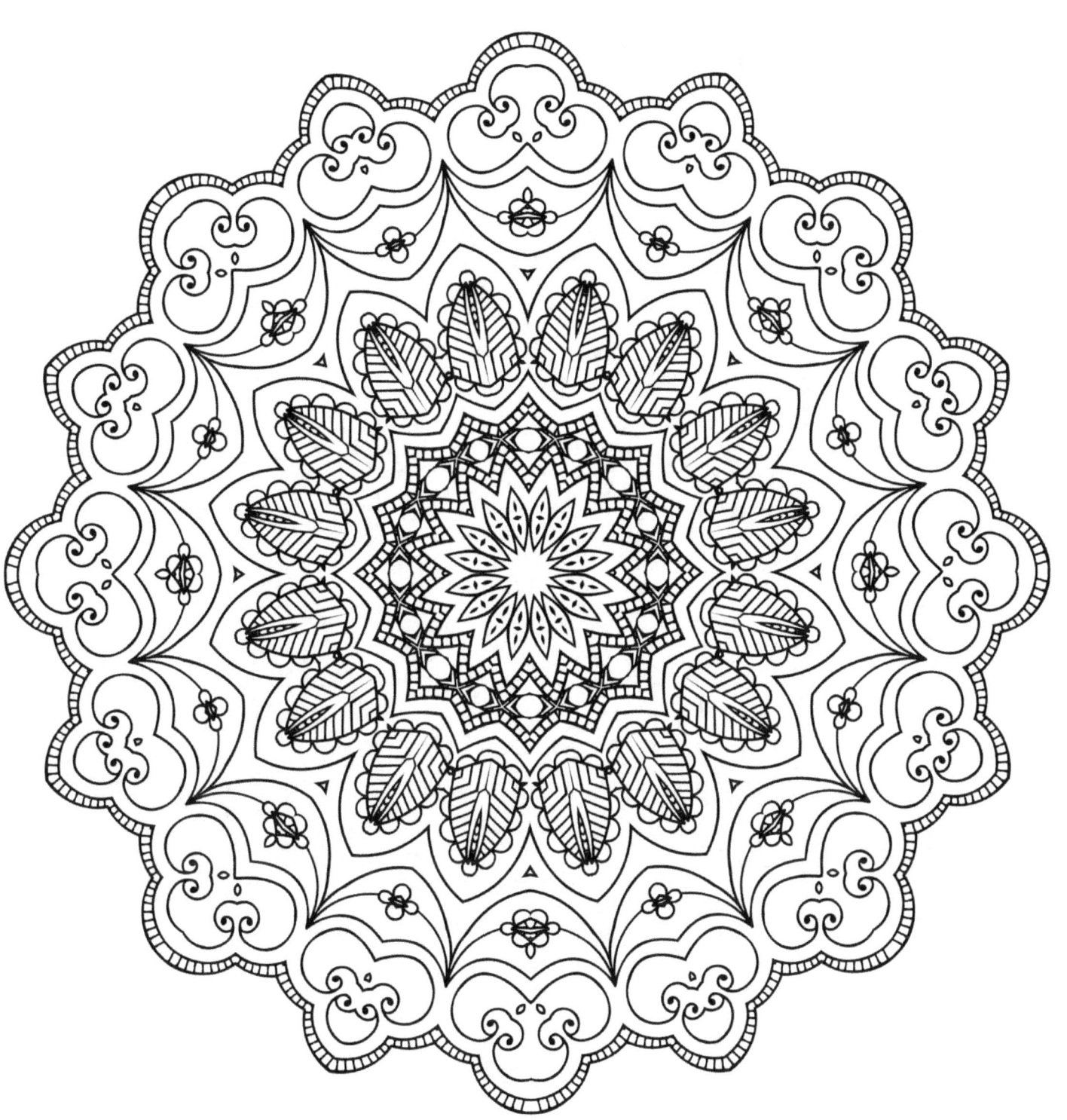

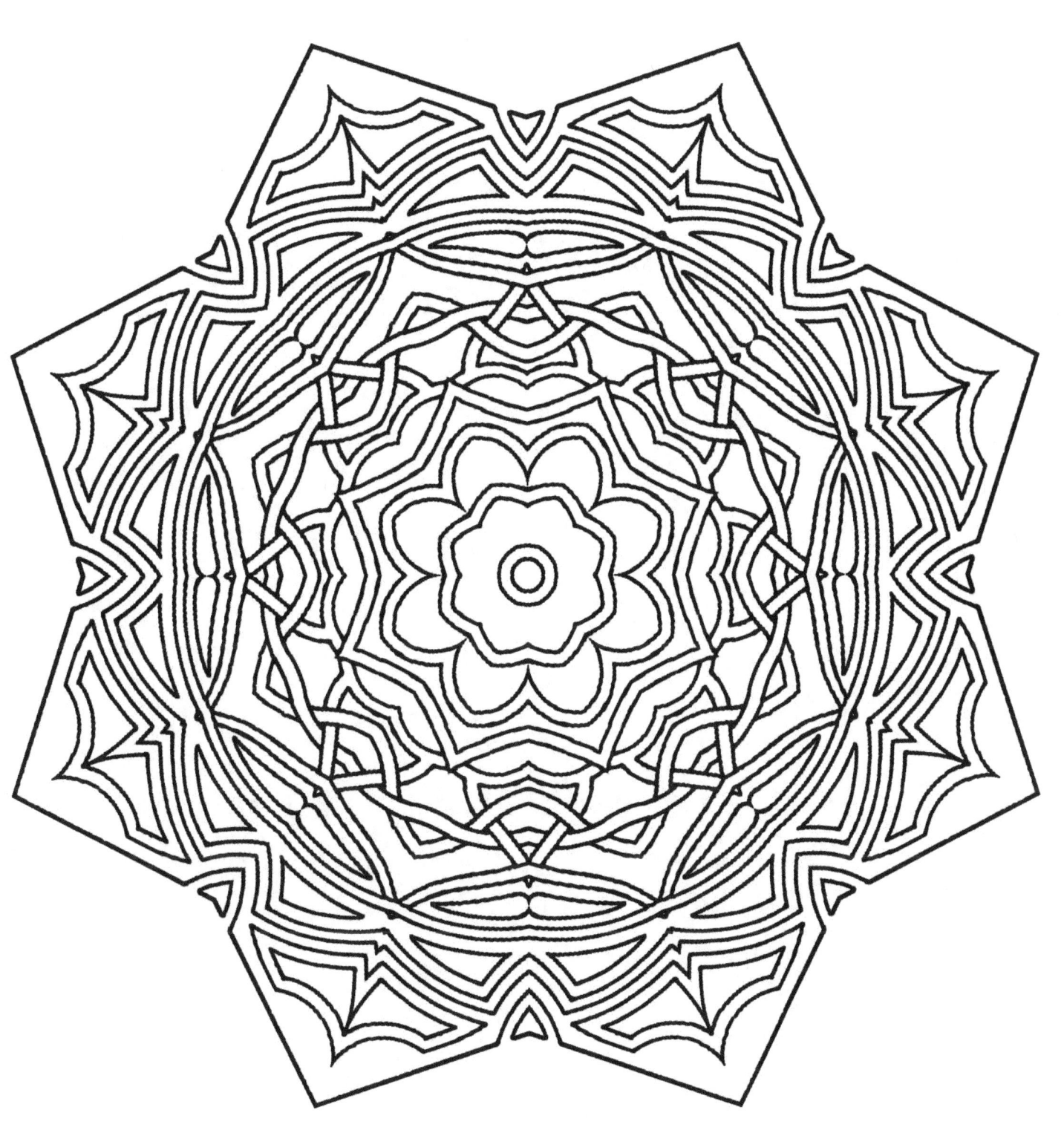

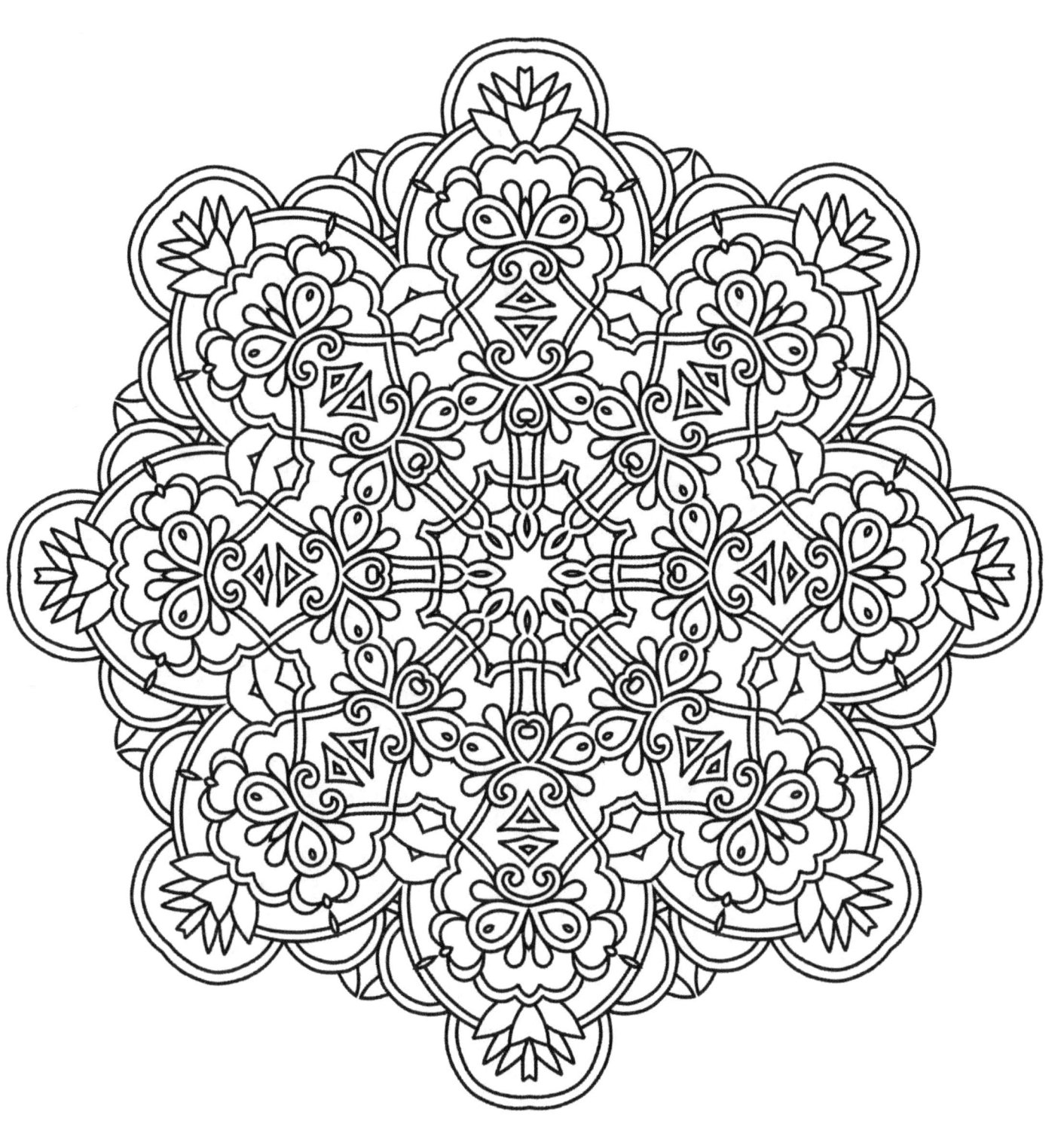

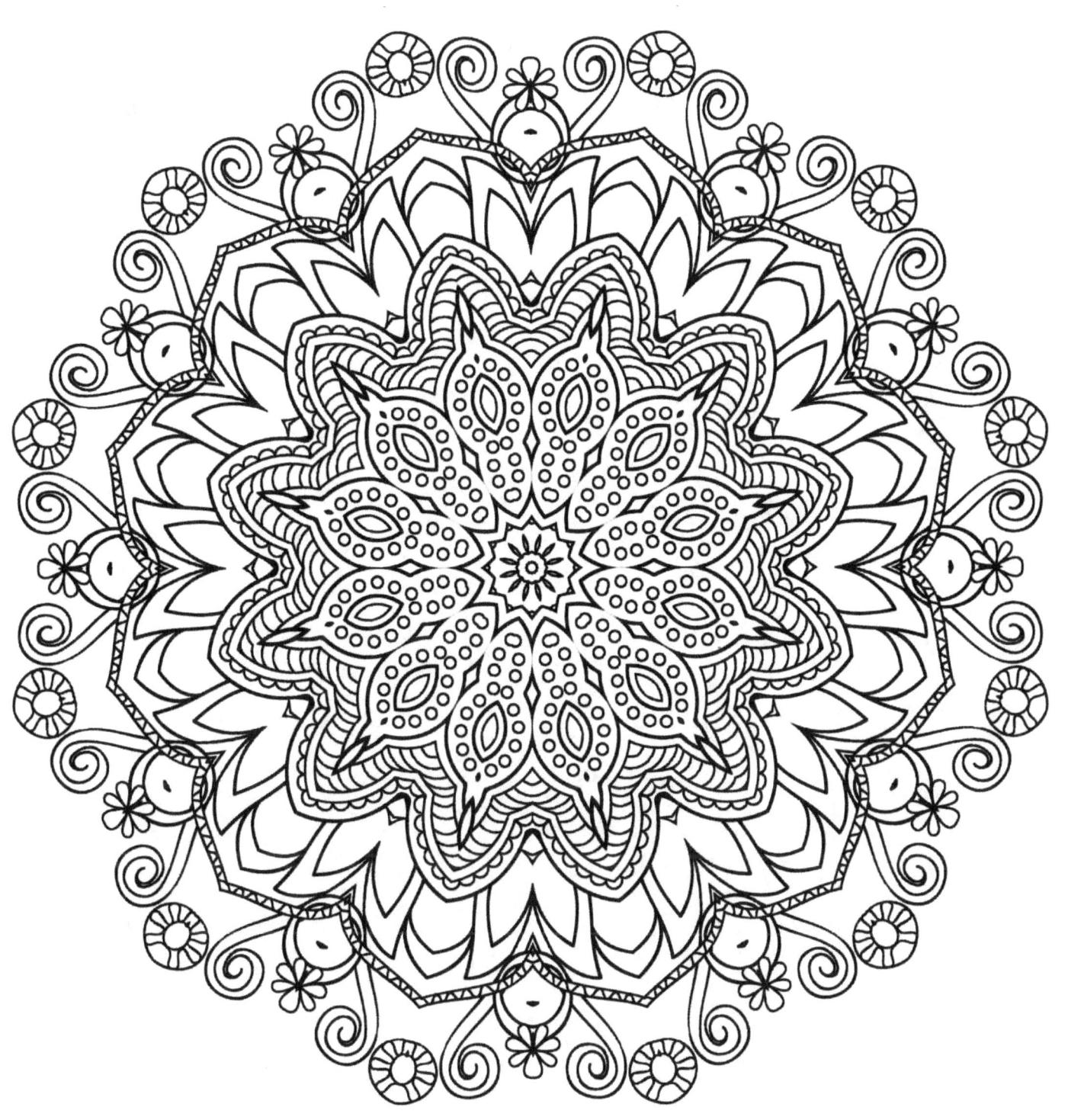

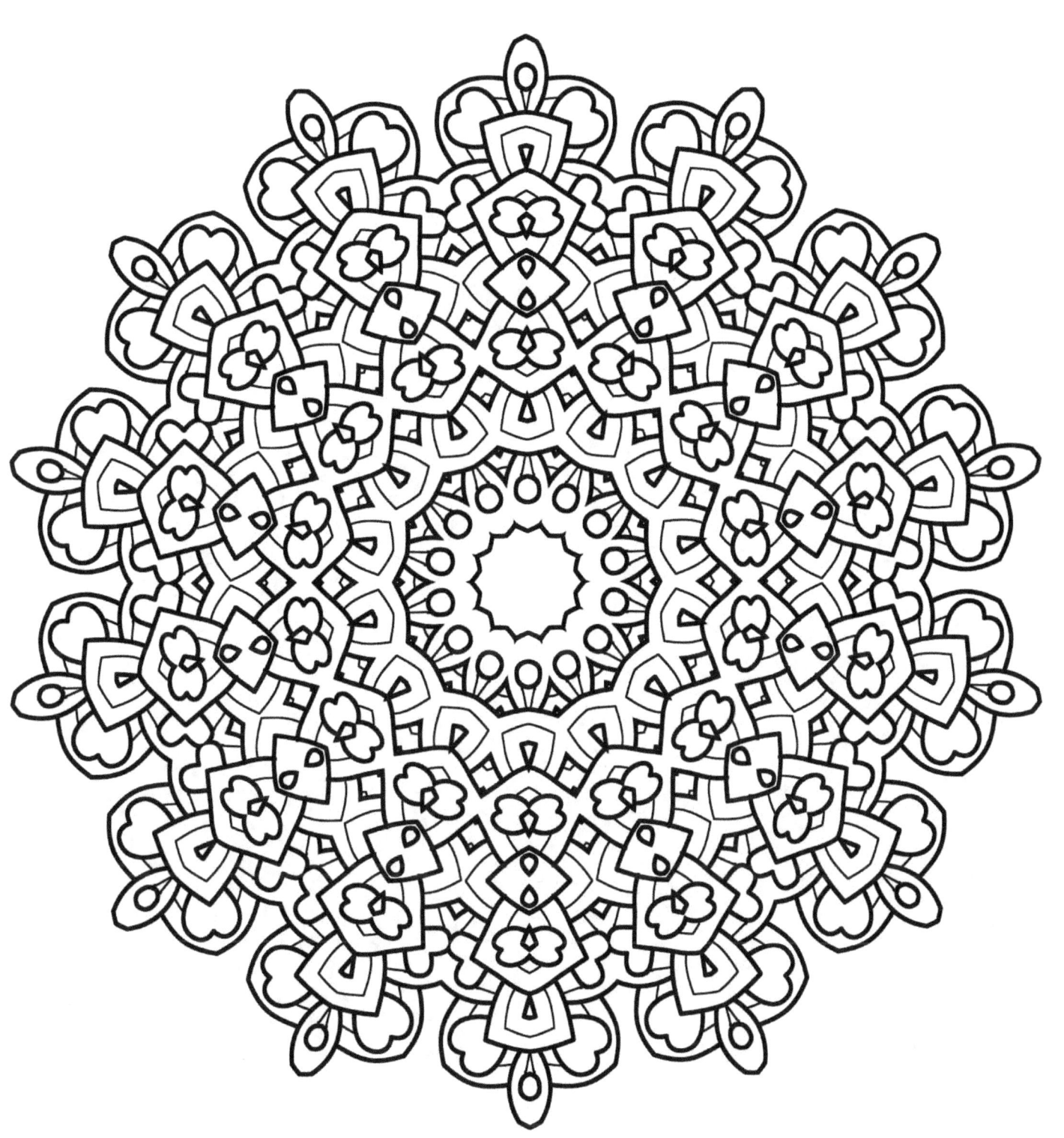

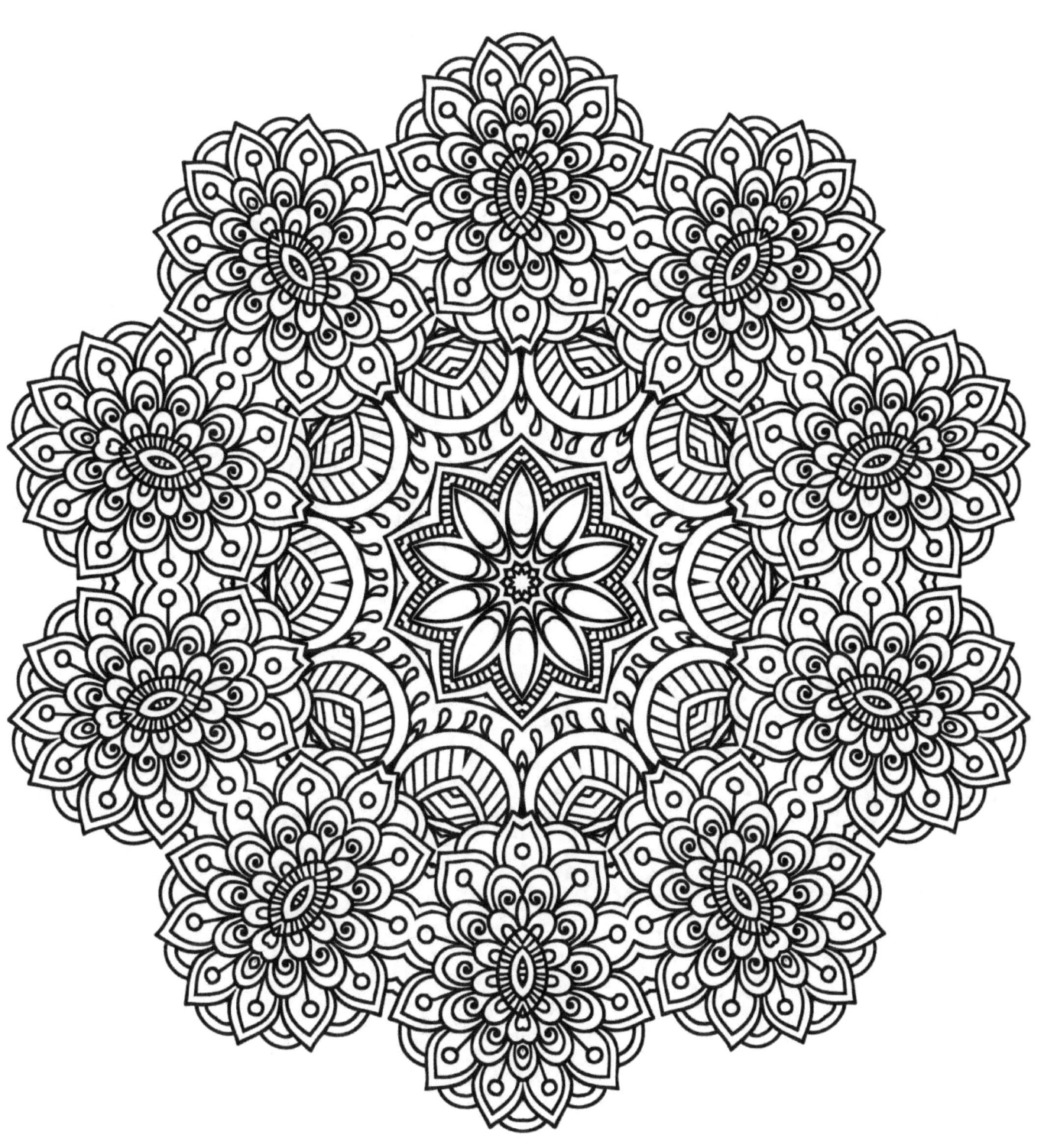

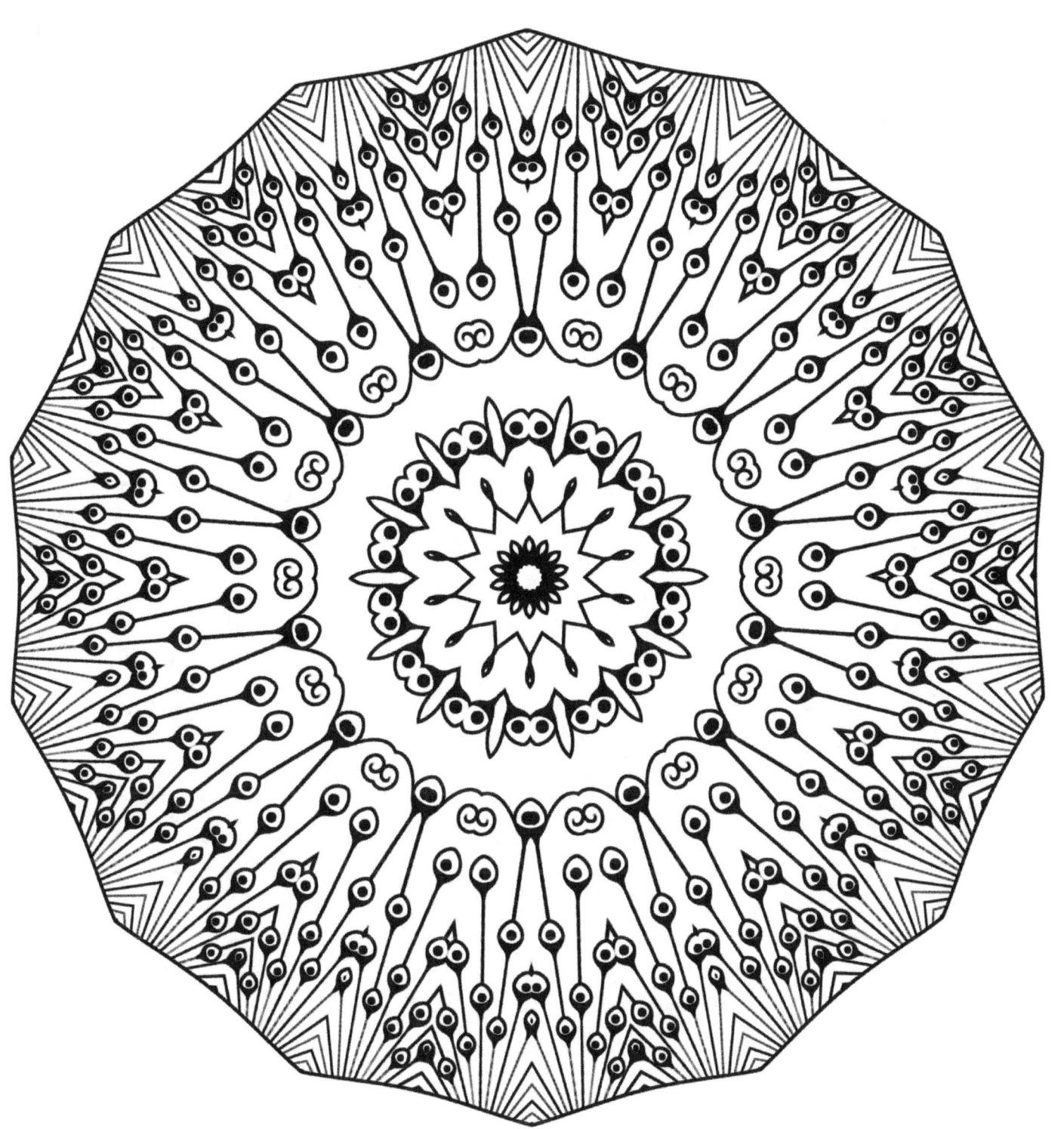

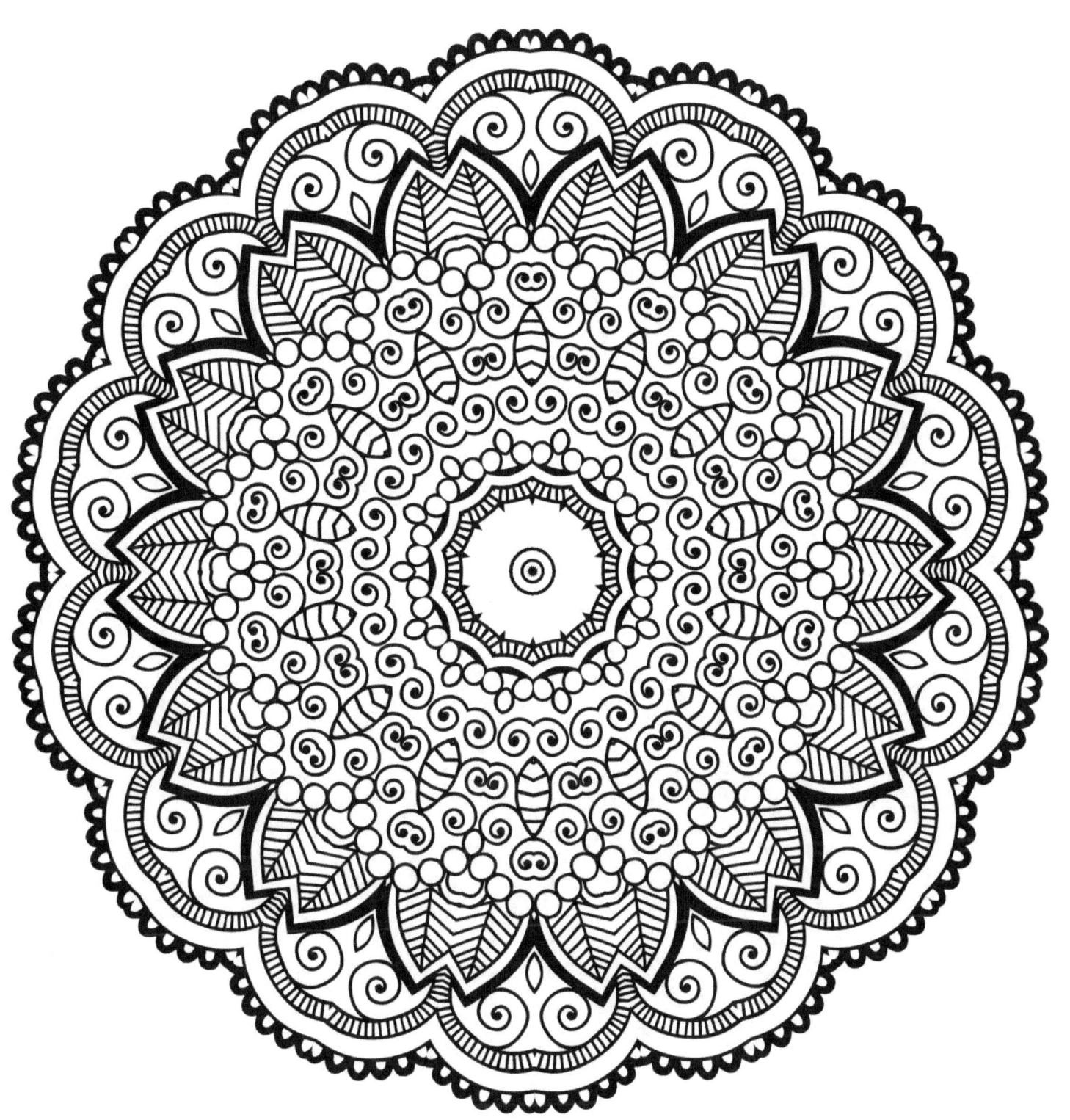

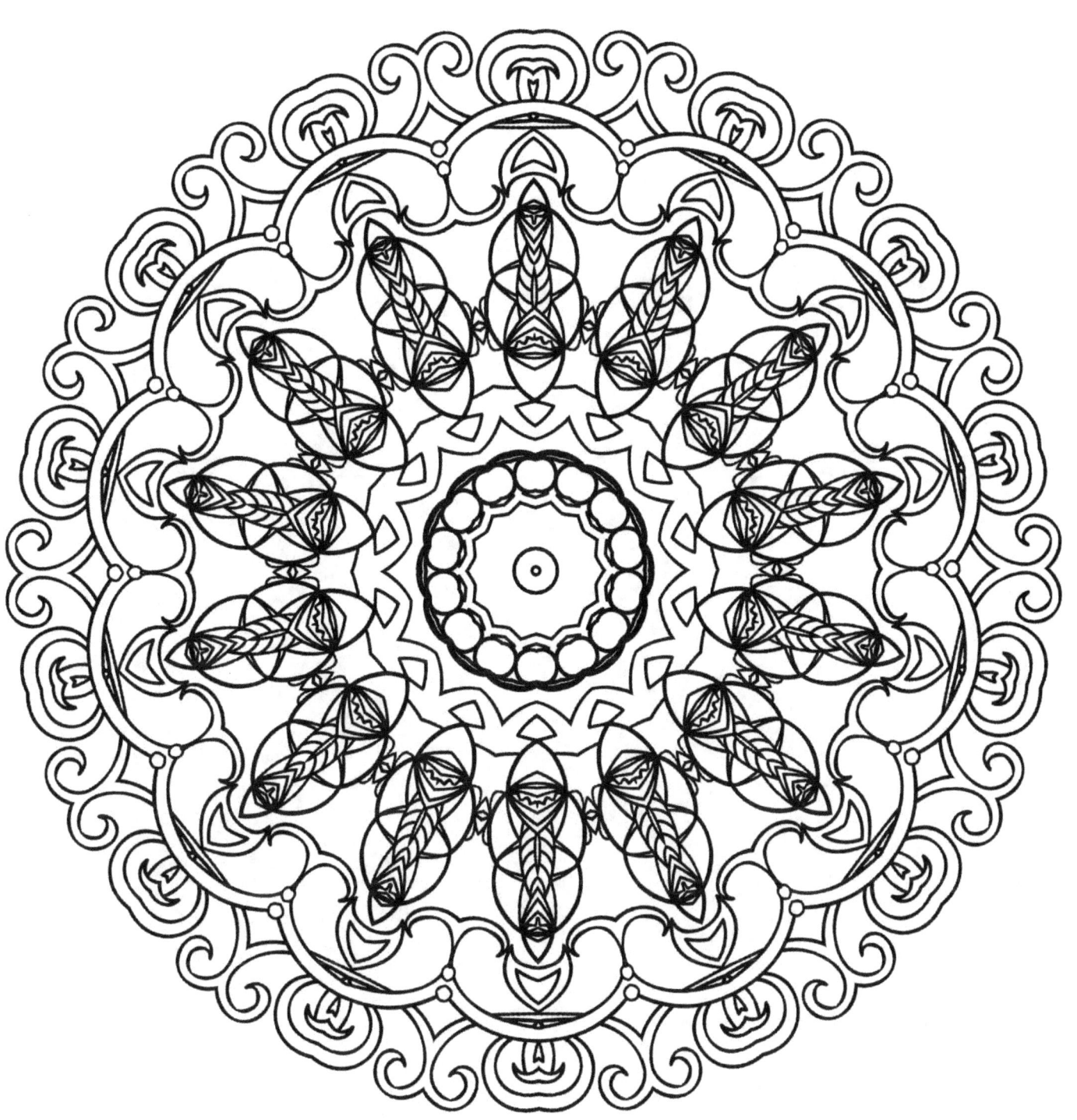

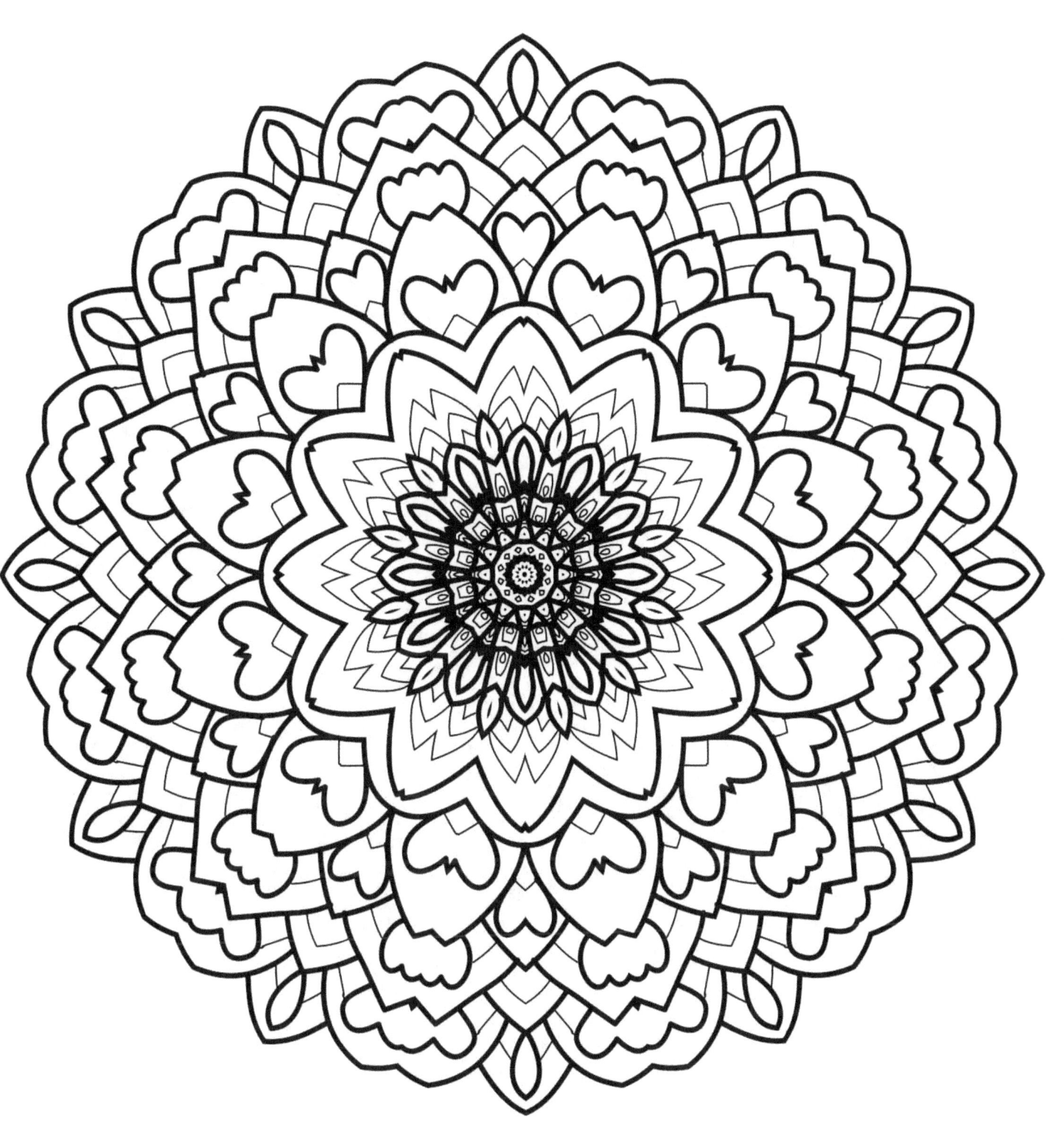

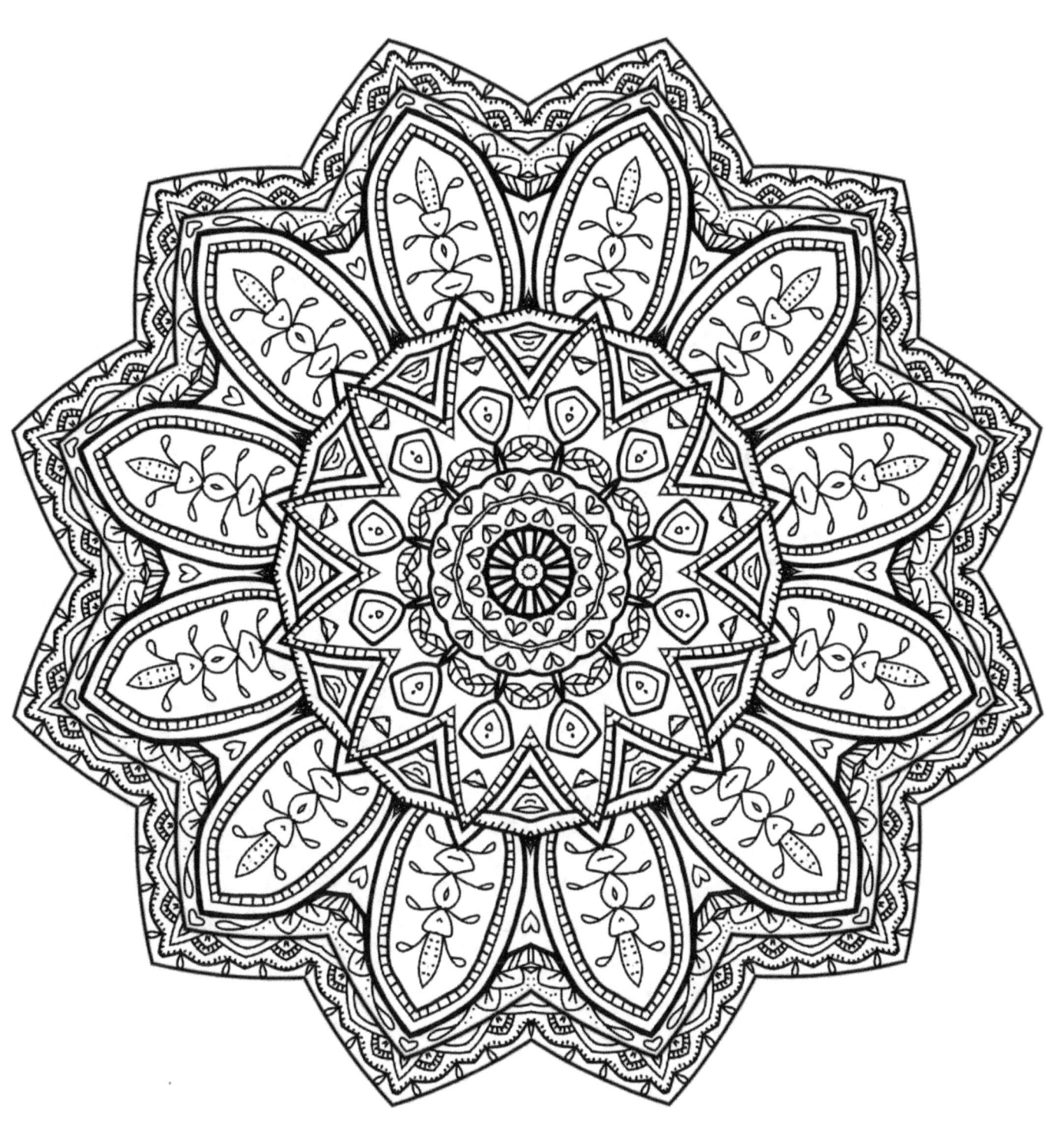

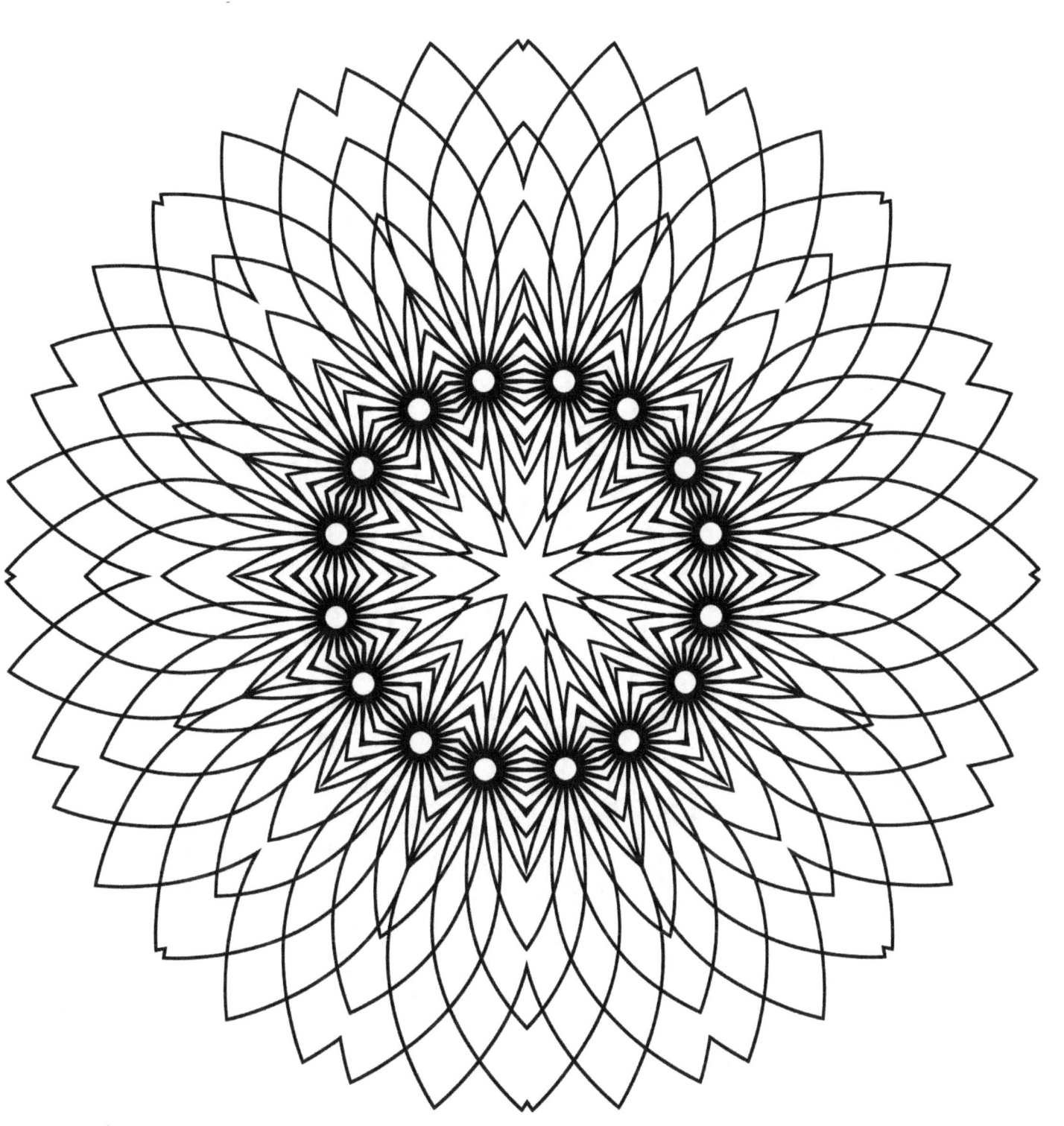

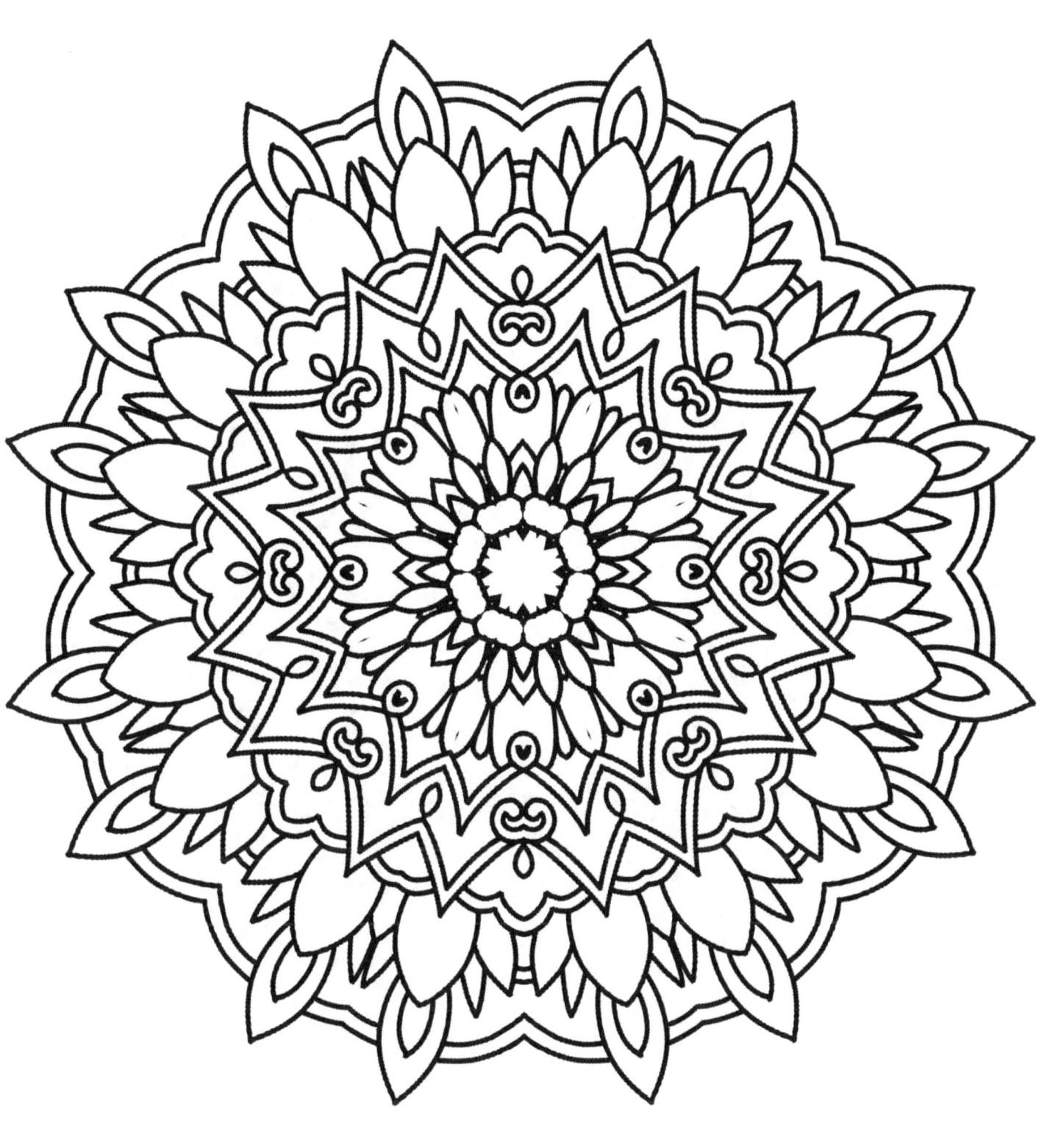

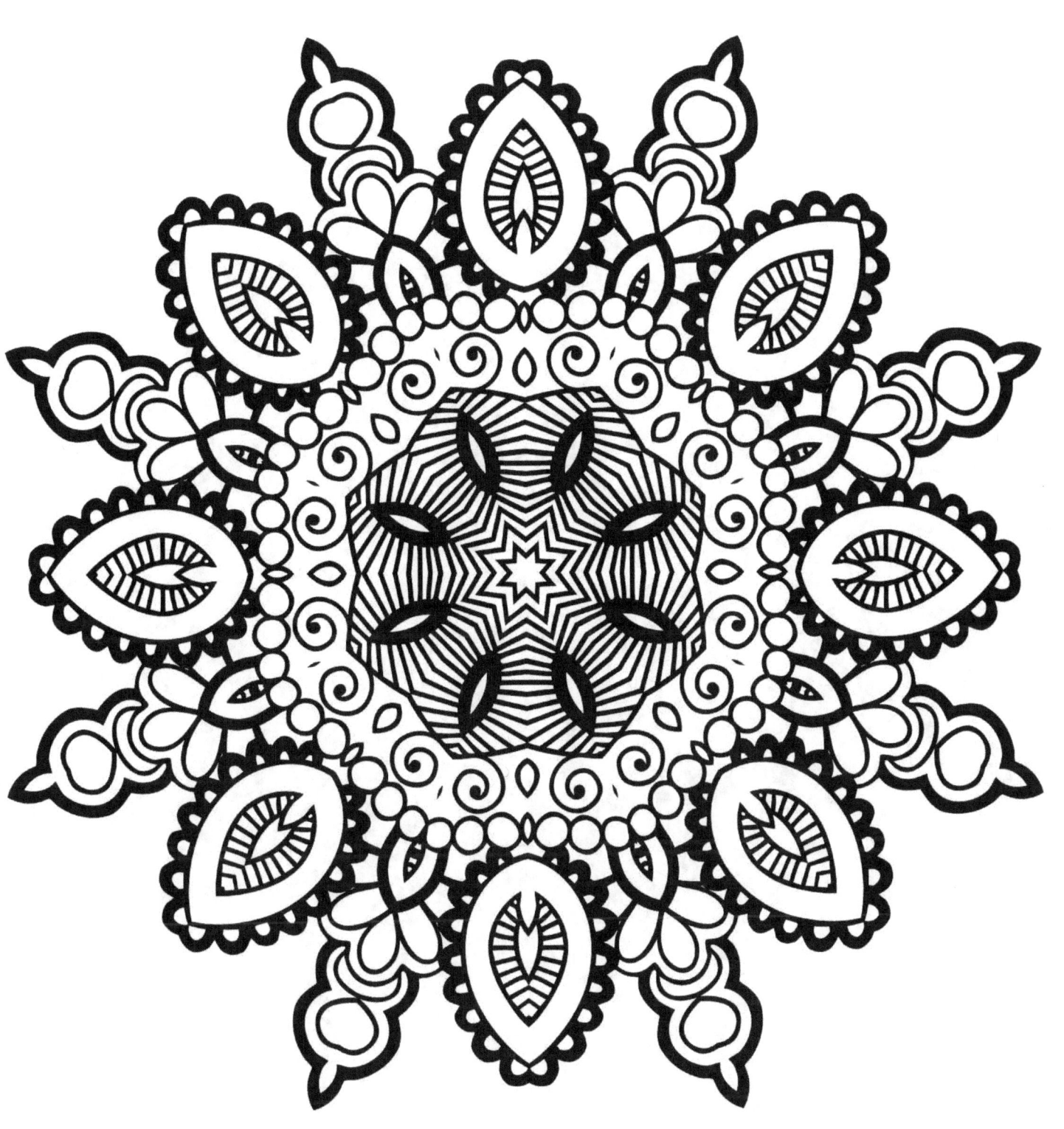

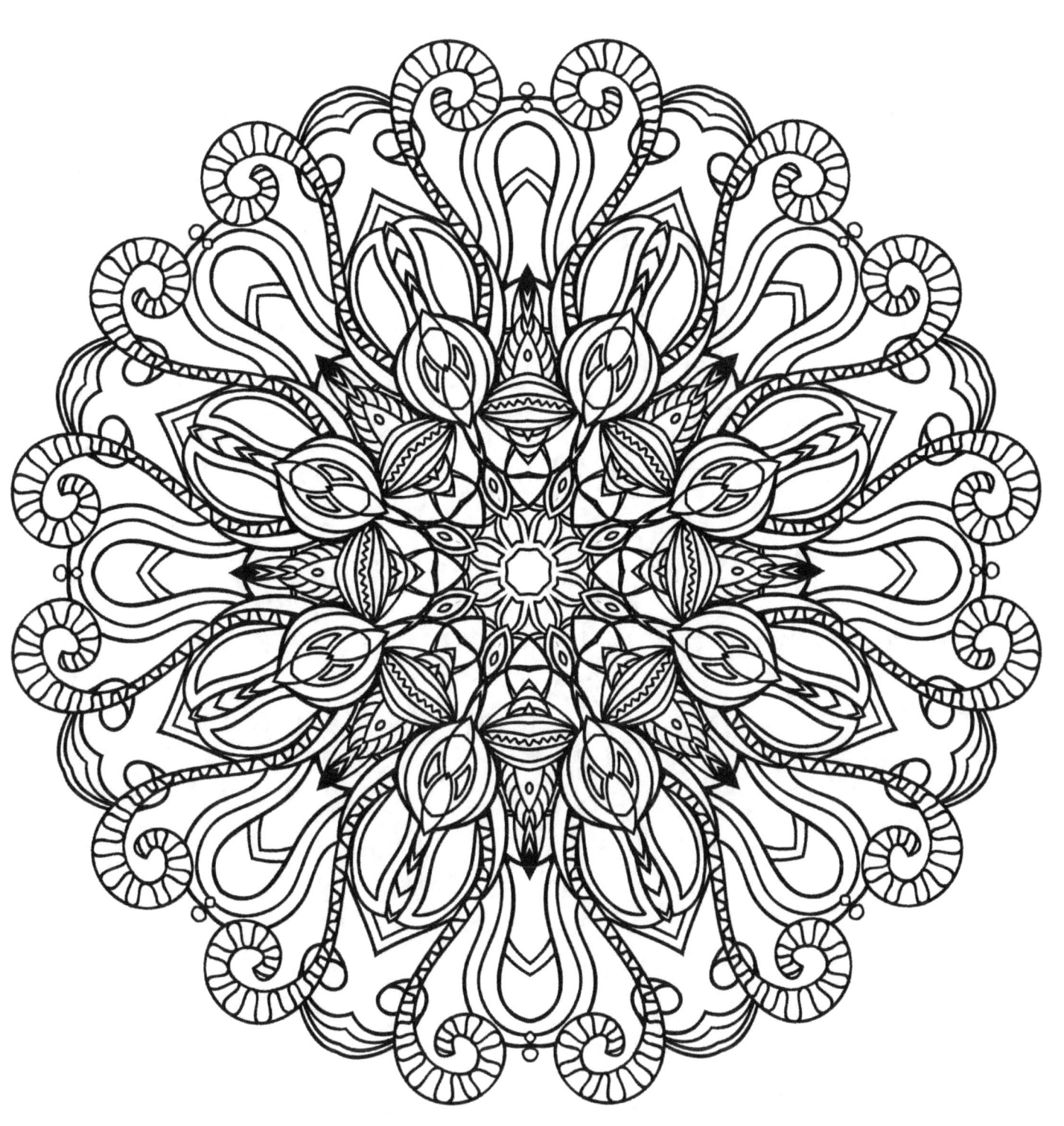

Mandala Designs
Adult Coloring Book

In this coloring book, I have included thirty delightful illustrations to motivate your imagination and inspire your inner-artist. Each drawing, ranging from moderate to more challenging difficulty levels, invites you to experiment and play with colors, letting them relax your mind and relieve your stress. If you like this book, please take a moment to post a review on www.amazon.com

Enjoy.

Samantha Moore

About Samantha Moore
Since childhood artist Samantha Moore has been experimenting with colors and their influence on mood and relaxation. She has a degree in Graphic Design, a diploma in Art History and is a Reiki Certified Therapist.

Copyright © 2017 L. Romo. All rights reserved. With the exception of photocopying for personal use and book review, no part of this book may be reproduced in any form without the written permission of the copyright owner.

Mandala Designs Adult Coloring Book

ISBN-13: 978-1979957533
ISBN-10: 1979957533

Please feel free to contact us if you have any questions or comments:
whatacolourfulworld@mail.com

You may also like:

We would love to receive your comments. Please, find a moment to write a review on Amazon.com

Thank you.